LEGENDARY LC

OF

BEND

OREGON

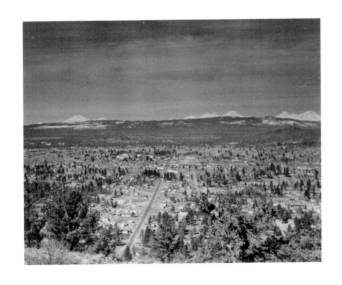

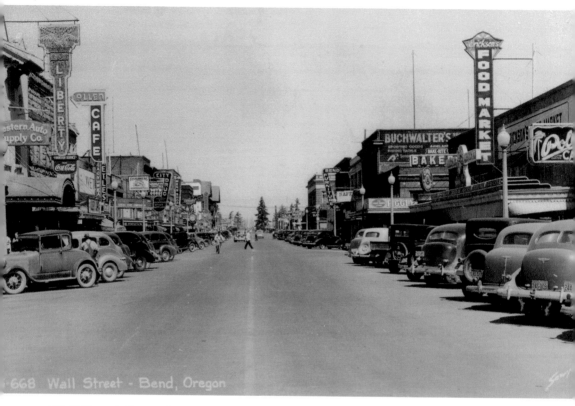

668 Wall Street - Bend, Oregon

Wall Street, Bend, Oregon
Pictured is downtown Bend, Oregon, looking north on Wall Street in 1938. At the time, most of Bend's businesses, including grocery stores, were located in the downtown core. Wall Street was also the route of US Highway 97, the main north–south route east of the Cascades. (Courtesy of Deschutes County Historical Society.)

Page 1: Bend, Oregon
The city of Bend rests at the eastern foot of the Cascade Range. (Courtesy of Deschutes County Historical Society.)

LEGENDARY LOCALS
—— OF ——

BEND

OREGON

LES JOSLIN

LEGENDARY
LOCALS

Legendary Locals is an imprint of Arcadia Publishing
Charleston, South Carolina

Printed in the United States of America

Library of Congress Control Number: 2015942299

For all general information, please contact Arcadia Publishing:
Telephone 843-853-2070
Fax 843-853-0044
E-mail sales@arcadiapublishing.com
For customer service and orders:
Toll-Free 1-888-313-2665

Visit us on the Internet at www.arcadiapublishing.com

Dedication
To my wife, Pat, and daughters, Amy and Wendy, who moved to Bend with me in 1988

On the Front Cover: Clockwise from top left:
Christina "Kiki" Cutter, Olympic skier (Courtesy of National Ski and Snowboard Hall of Fame; see page 118), Dan J. McLennon, pond monkey (Courtesy of Deschutes County Historical Society; see page 91), Leslie A.C. Weldon, forest supervisor (Courtesy of Oregon Forest Resources Institute; see page 98), Bill Healy, Mount Bachelor founder and developer (Courtesy of Deschutes County Historical Society; see page 24), George Palmer Putnam, newspaperman (Courtesy of Deschutes County Historical Society; see pages 56–57), Owen M. Panner, federal judge (Courtesy of Deschutes County Historical Society; see page 69), Leon E. Devereaux Jr., US Navy aviator (Courtesy of Leon Devereaux; see page 104), Kathleen Eloisa "Klonkike Kate" Rockwell, entertainer and humanitarian (Courtesy of Deschutes County Historical Society; see page 110), Alexander M. Drake, founder (Courtesy of Deschutes County Historical Society; see page 18).

On the Back Cover: From left to right:
Ann Markel, Maude Vandevert, Marian Wiest, Florence Young, Ruth Reid, and Norma Richardson, Bend schoolteachers in the early 1900s (Courtesy of Deschutes County Historical Society; see page 77), Deschutes National Forest supervisor Ralph W. Crawford; rangers Henry Tonseth, Harold Nyberg, and Homer Oft; fire control officer Gail Baker; and ranger Joe Lammi (Courtesy of Deschutes County Historical Society; see page 93).

CONTENTS

ACKNOWLEDGMENTS

Mission Impossible! That is what I accepted when I agreed to produce this *Legendary Locals of Bend* title in Arcadia Publishing's series, which "delves into the history of some of the unique individuals and groups, past and present, who have made a memorable impact on their community throughout its history."

The word "some" enabled me to profile just a few of the many fascinating people from all walks of life who have lived in and contributed to this place called Bend since its Euro-American discovery. Not all who might qualify as legendary locals could be included, and in all 10 chapters, some tough calls had to be made. I made those calls, and I alone am responsible for them. However, I have not created this book alone, and I am greatly indebted to those who helped me identify, obtain, and process images of the diverse legendary locals who populate these pages.

Foremost among these are the leadership, staff, and volunteers of the Deschutes County Historical Society and its Des Chutes Historical Museum. Kelly Cannon-Miller, executive director of the society and a legendary local in her own right, not only offered the opportunity to produce this book but provided access to the museum's extensive research resources and photographic collections. Volunteer Tor Hanson compensated for my technological shortcomings and proved invaluable to the effort. Vanessa Ivey, museum manager, and Shea Hyatt, museum registrar, assisted.

Also key was Molly Black-Hissong, associate director of development at The High Desert Museum, whose connections there and at the *Bulletin* proved instrumental in obtaining more than a few of the images in this book. Others included well-connected writer Jim Crowell of the Deschutes Pioneers Association; Ron Paradis, director of college affairs at Central Oregon Community College; City of Bend and Deschutes County government sources; Ryder Graphics; and quite a few of the legendary locals profiled in this book as well as their friends, family members, and descendants. All image sources are credited.

I thank my wife, Pat, for assisting with scanning photographs and for putting up with the disruption yet another writing project brought into our home and lives.

INTRODUCTION

John Riis, a young US Forest Service ranger, rode out from the smoke of the Big Blowup of late August 1910, when three million acres of Idaho and Montana burned and 78 firefighters perished. He rode toward a new assignment in Bend, Oregon, east of the Cascade Range and arrived in a relatively new land on the cusp of change. This change would transform Bend, the sleepy new town of 536 souls in which he dismounted, into a small but thriving industrial city of 10 times that number within as many years. A century later, about 80,000 people called Bend home.

At first disdained by early explorers and emigrants who passed through en route to the verdant Willamette Valley, higher and drier Central Oregon was wrested from nomadic Native Americans after the Civil War by ranchers who grazed sheep and cattle, followed in a few decades by homesteaders and irrigation farmers. These pioneers settled a small community on the upper Deschutes River that became known as Bend. Alexander M. Drake, credited as Bend's founder, arrived in 1900. Others joined him, set up shop, and incorporated the city of Bend in 1905. Among these were speculators and developers, interested in buying land for resale to future settlers and acquiring timberlands from which to reap future profits. The coming change, based on timber and transportation, would bring some of them success.

Timber and transportation were "the two interlocking ingredients of Central Oregon's developing economic base" that historian Philip Cogswell Jr. wrote "brought wealth to some and jobs to thousands" during the early decades of the 20th century. The timber was ponderosa pine, called western yellow pine until the early 1930s, "an estimated 26 billion board feet of it, in open forests on flat or gently sloping ground, waiting, seemingly, for someone to come and cut it," as Cogswell so aptly put it. But there was a hitch: getting that timber to market. "Central Oregon [in 1910] was virtually isolated from the rest of the nation, including other parts of Oregon, and the exploitation of *Pinus ponderosa* would have to wait for a railroad."

Don P. Rea, first editor of the *Bend Bulletin*, had opined in 1903 that, as soon as Bend saw a railroad, it would see "the logs moving toward the mills at Bend, and thousands of men . . . working in the mills and in the woods." Prominent geologist Israel C. Russell, who assessed Central Oregon's water resources that same year, agreed in 1905 that "the yellow pine forests" of Bend's hinterlands "are not only extensive, but contain magnificent, well-grown trees, which will be of great commercial value when railroads . . . bring them within reach of markets."

Access to timber markets and acquisition of timber resources, however, did not have to wait for arrival of the railroad. Indeed, 15 years before railroad magnates James J. Hill of the Northern Pacific and Great Northern Railroads and Edward H. Harriman of the Union Pacific and Southern Pacific Railroads began their legendary race toward Bend, their timber industry counterparts had begun acquiring timber holdings from the public domain in the region. Some of these public timberlands were obtained legally by private individuals and companies under laws that encouraged settlement and development of the West. As time passed, a "timber rush" led to widespread corruption and perversion of these laws. Finally, on July 31, 1903, Pres. Theodore Roosevelt withdrew public timberlands in the area from acquisition under some of these laws. Remaining public timber was incorporated into existing federal forest reserves, which were renamed national forests in 1907.

The railroad arrived in Bend on October 5, 1911. It was celebrated then (and has been ever since) as Railroad Day. James J. Hill drove a golden spike, marking completion of the Oregon Trunk Railroad route to Central Oregon, and the first train arrived in Bend to be met by most of the townsfolk, a brass band, and speeches. Access to markets for the area's timber was assured.

In 1916, two Minnesota-based timber giants, the Shevlin-Hixon Company and the Brooks-Scanlon Company, opened the huge pine mills that gave birth to the timber-based economy of Central Oregon. Before long, each of those mills employed 600 men and probably twice that number of loggers. Bend boomed as a timber town for decades. Farmers and ranchers also benefitted from railroad access to markets, and passenger trains encouraged tourism.

Today, its sawmills long closed, Bend is no longer a timber town, yet its economic base was vastly strengthened by extensive diversification. At the age of 110 years in 2015, Bend is a vibrant city with a population much more than 100 times that of the town in which John Riis dismounted. It is the attractive, prosperous, and rapidly growing core city of an attractive, prosperous, and growing Central Oregon. It is a city which values its past as it builds its future. It is a city which welcomes newcomers and new ideas and enterprises.

A few of the "legendary locals" from all walks of life—people who in many ways helped and continue to help Bend evolve or who otherwise have distinguished themselves as members and representatives of this unique American city—are remembered and recognized in this book.

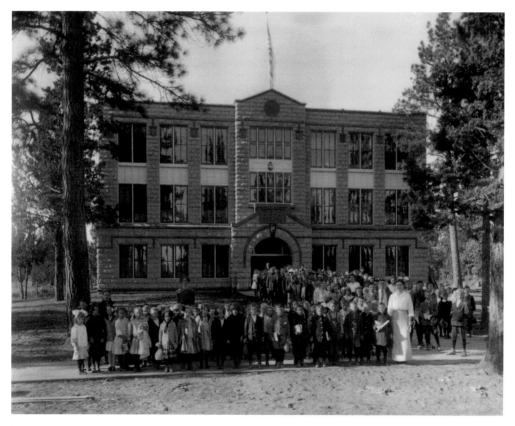

Reid School
Teachers and pupils gathered in front of Reid School. Built in 1914 on Northwest Idaho Avenue, just south of the downtown business district, the historic building now houses the Des Chutes Historical Museum and the offices of the Deschutes County Historical Society. (Courtesy of Deschutes County Historical Society.)

CHAPTER ONE

Explorers, Pioneers, and Settlers

The upper Deschutes River country appealed to Native Americans long before Euro-Americans discovered it, explored it, settled it, and founded Bend in perhaps the river's most welcoming location. These nomadic hunter-gatherers, most recently Northern Paiutes from the arid sagebrush steppes to the east, visited the area as part of their "seasonal round." Following hunting and gathering opportunities, they camped along the river.

The fur trade first brought Euro-Americans to Bend's future environs during the early 19th century. Fur trappers from Astoria and Fort Vancouver searched for beavers along Central Oregon's waterways. Nathaniel Wyeth passed through in search of commercial opportunities. Exploration brought an expedition, led by Capt. John C. Fremont of the US Army Corps of Topographical Engineers, through the future Bend area in December 1843. In 1845, Stephen Meek led immigrants through in an attempt to find a direct route from the Snake River to the Willamette River. In 1855, Army topographical engineers led the Pacific Railway Survey through the area. Oregon became a state in 1859.

Settlement of the Bend area began in the 1870s. Pioneer rancher Thomas Geer filed and patented a land claim on the site of the future city that he sold to John Y. Todd in 1877. Todd named this the Farewell Bend Ranch, for which Bend was later named. John Sisemore bought Todd's ranch in 1881 and applied for a post office in 1886. Because the name Farewell Bend had been taken, postal authorities shortened it to Bend, and the future city had a name. Other settlers followed, and in 1900, developers interested in obtaining land for resale to future settlers arrived. Passage of the Homestead Act of 1865, the Timber and Stone Act of 1878, and other acts to encourage settlement did what they intended, while passage of the Carey Act of 1894 stimulated irrigation agriculture. At the beginning of the 20th century, Bend's founders provided the first irrigation water to the area. The ponderosa pine forests that surrounded Bend promised an eventual timber boom.

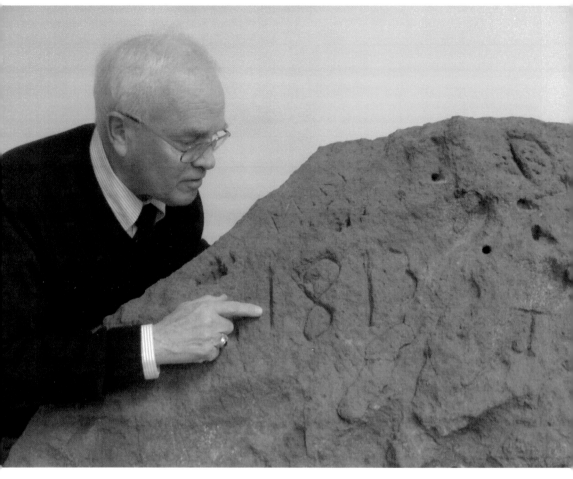

An 1813 Rock, Bend's First Euro-American Visitors?
The date 1813 and several initials inscribed in a volcanic tuff boulder—found above the Deschutes River south of Bend in the 1970s—may commemorate the first visit of Euro-American visitors to the future town site. If so, those visitors predated the recorded visit of Peter Skene Ogden and his Hudson's Bay Company contingent, long believed to be the first Europeans to enter the area, by a dozen years. The rock is on exhibit in the Des Chutes Historical Museum in Bend. Who the 1813 visitors may have been remains the subject of research, conjecture, and debate.

John Jacob Astor, eager to duplicate the success of the Hudson's Bay Company fur trapping enterprise, sought his own fur empire in the Pacific Northwest. He founded the Pacific Fur Company in 1910 and established a trading post in present-day Astoria in 1911. From there, scouts set out in search of rivers that beavers might inhabit. The War of 1812 halted Astor's enterprise when the British claimed Astoria and renamed it Fort George. The Hudson's Bay Company took over Astor's fur and trading posts, and his trappers were left to fend for themselves.

One fur trapping expedition, perhaps led by Donald McKenzie, could have made it to the Bend country in 1813. Other trapper-explorer bands were scattered in the Deschutes Basin. Among them were many whose names might correspond with the initials on the rock. It is feasible that some small party from one of these made it into the Bend area on the Deschutes River.

The rock probably was part of a vertical face of volcanic tuff quarried more than a century after it was inscribed. This tuff was a popular building material in early Bend. A soft stone easily quarried, it hardens with age. (Photograph by Pat Joslin.)

Peter Skene Ogden, Fur Trader and Trapper
As a Hudson's Bay Company fur trader, Peter Skene Ogden explored much of British Columbia and the American West. In the fall of 1826, after ascending the Deschutes and Crooked Rivers and exploring the Harney Basin, Ogden's party traveled westward and became the first Euro-Americans of record to visit the Newberry Caldera and explore the unmapped territory of Central Oregon. Ogden, Utah, is named for him. (Courtesy of Deschutes County Historical Society.)

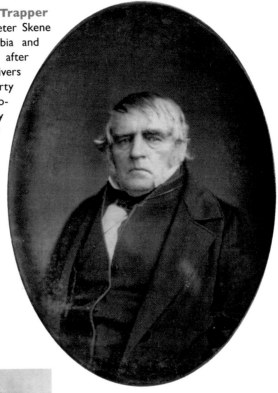

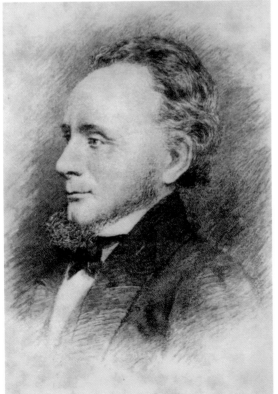

Nathaniel J. Wyeth, Businessman and Explorer
Nathaniel J. Wyeth was a businessman from Cambridge, Massachusetts, seeking to establish trading operations in the Columbia Basin. In late 1834 and early 1835, he pursued deserting Hawaiian laborers up the Deschutes River. For two months he explored the river, passing through the future site of Bend and enduring many winter hardships. Generally unsuccessful in his efforts, Wyeth left Oregon in 1836 and returned to his Massachusetts business interests. (Courtesy of Deschutes County Historical Society.)

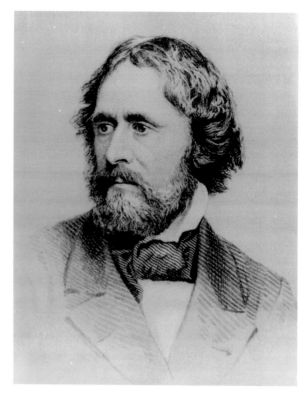

John Charles Fremont, Explorer and Engineer

A decade after Wyeth's visit, Capt. John Charles Fremont of the US Army Corps of Topographical Engineers passed through the Bend country in December 1843 as he freelanced his most significant contribution to western exploration.

Along with famed scouts Thomas "Broken Hand" Fitzpatrick and Christopher "Kit" Carson, Fremont's party of some 45 had completed its assigned reconnaissance of the Oregon Trail. Fremont decided not to return by the same route, as directed by his orders, and led his men southward from The Dalles along the eastern side of the Cascade Range, over the Sierra Nevada, and back across the Great Basin. The Oregon part of this expedition lasted from November 25 to December 26. December 4 found Fremont's party traveling southwesterly from a camp near present-day Sisters, Oregon, generally following the route of today's US Highway 20 across an open plain toward the Deschutes River. They likely camped on a tributary called Tumalo Creek at today's Fremont Meadow in Shevlin Park, a few miles west of Bend. On December 5, they rode upstream along the western bank of the Deschutes River, passing Dillon Falls and Benham Falls before they made an early camp at what had been an Indian camp. Fremont's party made the first significant observations of the area where Bend was founded some 60 years later.

Born in Savannah, Georgia, in 1813, Fremont attended the College of Charleston in South Carolina before becoming an assistant engineer in the Topographical Corps, in which he was commissioned a second lieutenant in 1838. His 1841 marriage to Jessie Benton, daughter of politically powerful Sen. Thomas Hart Benton of Missouri, helped make possible the three expeditions that earned him the sobriquet "Pathfinder." Fremont's expeditions provided both information and inspiration for settlement of the West.

Fremont helped conquer California during the Mexican War, served California briefly as a US senator, was the first Republican Party presidential candidate, served as a major general during the Civil War, and served as Arizona territorial governor before he died in New York City in 1890. He remains a controversial character in American history. (Courtesy of Deschutes County Historical Society.)

Henry Larcom Abbot, Explorer and Engineer
Born in Massachusetts in 1831, Henry Larcom Abbot graduated from West Point with a degree in military engineering in 1854. After leading units of the 1855 Pacific Railway Survey through the Bend area, he served a distinguished career as an Army engineer, retired in 1895 as a brigadier general, and died in 1927. Camp Abbot, the World War II combat engineer training center south of Bend, was named for him. (Courtesy of Deschutes County Historical Society.)

John Strong Newberry, Physician and Scientist
Dr. John Strong Newberry, born in Connecticut in 1822, was a prominent physician, geologist, and botanist who accompanied Lieutenant Abbot's party during its 1855 exploration of Central Oregon. After extensive explorations in the West and service as a medical officer during the Civil War, he taught at Columbia College for 24 years. He died in 1892. Newberry Caldera and the Newberry National Volcanic Monument south of Bend are named for him. (Courtesy of Deschutes County Historical Society.)

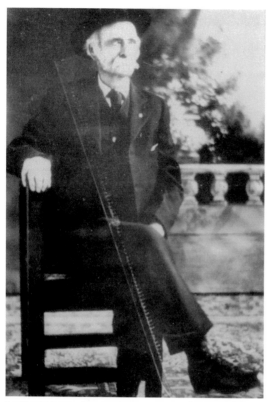

**Marshall Clay Awbrey,
Pioneer Namedropper**
Missourian Marshall Clay Awbrey's legacy in
Bend is much greater than his contributions.
Awbrey Butte, Awbrey Glen, Awbrey
Road, and (in Jefferson County northeast
of Grizzly) Awbrey Mountain, all bear his
name. A veteran of the Mexican War, he
arrived in the Bend area in the 1880s and
lived to see Bend grow from a frontier ranch
into an industrial city before he died in
Roseburg, Oregon, in the 1920s. (Courtesy
of Deschutes County Historical Society.)

John Y. Todd, Pioneer Rancher
Missourian John Y. Todd arrived in
Oregon in 1952 and ran a pack string
from Jacksonville to Portland. In 1856,
Todd moved east of the Cascade Range
and went into the cattle business. In 1877,
Todd bought the Farewell Bend Ranch—on
the Deschutes River where Bend was
founded—from Thomas J. Geer for $60
and two saddle horses. In 1881, he sold the
ranch to John Sisemore. Todd Lake, west
of Bend, is named for him. He died in Salem
in 1919. (Courtesy of Deschutes County
Historical Society.)

John Sisemore and William H. Staats, Early Bend Rivals
Two parallel streets south of downtown Bend are named for pioneer rivals John Sisemore—apparently camera-shy, thus the street sign—and William Staats—shown with wife and probable grandchild—whose stories also run parallel.

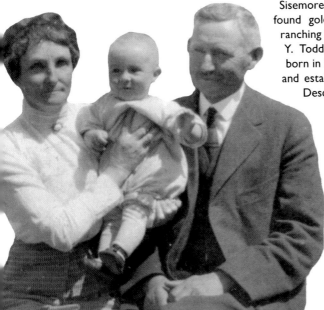

Sisemore moved west from Kentucky in 1853, found gold in California, and invested in cattle ranching in the Klamath Falls area. He bought John Y. Todd's Farewell Bend Ranch in 1881. Staats, born in Monmoth, Oregon, came to Bend in 1879 and established a home on the east bank of the Deschutes River in 1881.

Sisemore became Bend's first postmaster in 1886. The post office closed in 1893, but reopened six years later with Staats as postmaster. Sisemore built the Farewell Bend Hotel, which competed with Staats's Deschutes Hotel. To better compete, Sisemore built a bridge across the river. Construction of the first Pilot Butte Inn ended their feud. (Above, photograph by Les Joslin; left, courtesy of Deschutes County Historical Society.)

William Plutarch Vandevert, Pioneer Rancher

A son of Oregon pioneers, William Plutarch Vandevert was born in the Willamette Valley in 1854. He lived a "Wild West" life that began with driving horses to California at 15, working on a survey crew in Central Oregon at 17, carrying the mail through the Modoc War in his early 20s, and moving to Texas to ride for the fabled Hash Knife Outfit in 1876. He met and married schoolteacher Sadie Vinceheller, moving with her in 1884 to Arizona, where he worked until 1889. After a brief sojourn in New York, during which their sixth child was born, the family moved to land on the Deschutes River that Vandevert had admired while on that survey crew and established the Vandevert Ranch in 1892. He met Alexander M. Drake in Arizona and later helped him found Bend. A leading citizen, Vandevert died in 1944. (Both photographs courtesy of Deschutes County Historical Society.)

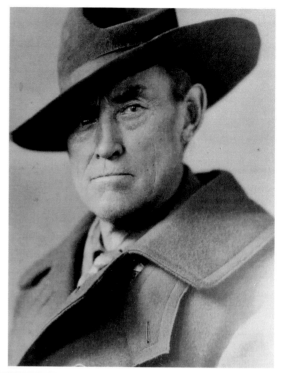

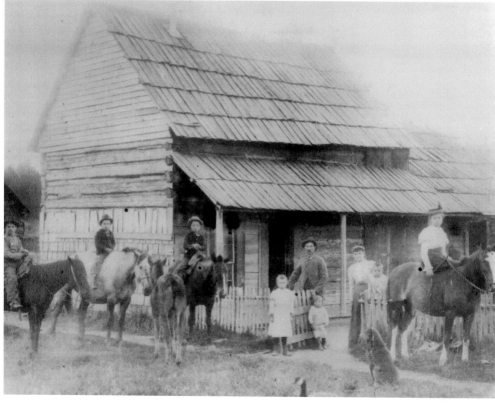

CHAPTER TWO

Founders, Builders, and Developers

Virtually every community in the United States identifies and reveres those who founded, built, and developed it. These pioneers are, indeed, legendary locals.

This chapter focuses on Bend's key founders, builders, and developers. Long accorded the title of founder is Alexander M. Drake, who, after learning of the future city's salubrious location on the banks of the Deschutes River from William Plutarch Vandevert in Arizona, arrived on those banks in 1900 to make his mark. Catalysts in this founding and early development were promoter Clyde McKay, who arrived that same year, and engineer Levi D. Wiest, who arrived in 1901. Among the future city's early developers and builders were Irish immigrant Hugh O'Kane and Minnesota brothers Ed and George Brosterhous, who constructed many of Bend's early edifices—many still in use. Harry A. "Ham" Miller founded the retail lumber company that supported early building efforts and remains in business.

William D. Cheney came from Seattle in 1911 to found the Bend Park Company, one of the West's first big land development efforts. He did not remain long enough to become a "local" in the city but became legendary for promoting the area in his 1911 publication titled *The Bend Book*. In that book, Cheney extolled the virtues of "a country so rich in resource that a city, not a town, but a *city*, must some day be built here." He helped found the Emblem Club, a short-lived but influential booster organization (described on page 40) to pursue this vision.

Four major events helped transform Bend from the small frontier town Cheney saw to the bustling city he envisioned. First, construction of irrigation canals during the early 1900s added family farm-based agriculture to ranching. Second, arrival of the Oregon Trunk Railroad in 1911 provided access to outside markets for Bend's agricultural products and timber resources, encouraging rapid development. Third, the large sawmills of the Shevlin-Hixon and Brooks-Scanlon companies began operations in 1916, and lumber exports brought additional wealth. Finally, long before Bend lost its timber town identity, recreation and tourism became major forces behind the city's growth and development.

Three legendary locals built on that last event. Bill Healy led development of Mount Bachelor as the state's premier winter sports area. Mike Hollern diversified the Brooks-Scanlon Corporation's operations to include land development. Bill Smith turned Brooks-Scanlon's abandoned sawmill into Bend's famous "Old Mill District."

Alexander M. Drake, Founder

Alexander M. Drake founded Bend. Born in Zenia, Ohio, in 1859, he grew up in St. Paul, Minnesota, as the sometimes sickly son of a pioneer railroad builder. At the end of the 19th century, Drake and his wife, Florence, went west to convalesce and possibly regain some of their fortune lost to the panic of 1893.

The Drakes arrived by covered wagon at a place in Central Oregon called Farewell Bend in June 1900. Florence's love of the area's natural beauty—"the majestic Cascades to the West and the Deschutes River in the foreground"—seems to have influenced her husband's selection of the site. About 20 people lived in the Deschutes Precinct of Crook County, Oregon, at the time. Drake made certain more soon would.

In October 1900, just four months after he arrived, Drake incorporated the Pilot Butte Development Company to irrigate arid lands around Bend as provided for by the Carey Act of 1894; he soon put Central Oregon on the irrigated agriculture map. In 1901, the Drakes built a fine log home, Drake Lodge, on a site overlooking the river and around which the town developed. Their home soon became the center of social, civic, and business life of the growing village of Bend. Drake platted Bend's town site in June 1904, and its 300 residents voted in December 1904 to incorporate as a city in January 1905.

Drake's various companies also built and operated Bend's first commercial sawmill, the first Central Oregon irrigation canal, a city water system, and the original Pilot Butte Inn. He founded the Deschutes Water, Power, and Light Company in 1909 and built the dam and original wooden powerhouse on the Deschutes River. On November 10, 1910, the first electricity was provided to Bend's business district. Drake's original turbines and generator produced power for parts of downtown Bend into the 21st century.

After a decade in Bend, Drake sold his holdings to Clyde McKay's Bend Company in 1911 and moved to Pasadena, California. Drake died there in October 1938, a year after the death of his wife.

"Had the Drakes chosen some other part of the West for their home," some have speculated, "Bend might have remained Farewell Bend, a village snuggled among the junipers and pines." Most, however, believe another pioneer— perhaps Clyde McKay— would have founded the city. (Courtesy of Deschutes County Historical Society.)

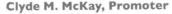

Clyde M. McKay, Promoter

Most recognize Alexander M. Drake as Bend's founder, but much of Bend was built through the efforts of such "successors" as Clyde M. McKay and his Bend Company associates, including brothers D.E. and A.O. Hunter.

Born in Chippewa Falls, Wisconsin, in 1877, McKay graduated from the University of Wisconsin in 1900 as a mechanical engineer. That same year, he came to Bend to cruise and consolidate timberlands for Midwestern companies—most notably Brooks-Scanlon and Shevlin-Hixon, which opened Bend's two large pine mills in 1916.

The Bend Company he led not only coaxed timber barons to the region but promoted construction of the railroad that made lumber exports possible. McKay and the Bend Company were the driving force behind Bend's development.

Even as he built Bend's infrastructure and launched its timber industry, McKay was appointed state fire marshal for the vast Deschutes timberlands in 1912. He organized the first private timber fire protection association in the area and was appointed state game warden in 1913, establishing the area's first fish hatchery and stocking the lakes with game fish. He promoted highway construction and guided the first moviemakers in the area. He was also an organizer and leader of the First Presbyterian Church. He established the first land title insurance business in Bend and competed with the *Bend Bulletin* in the newspaper business. He was a key member of many of Bend's business, civic, and fraternal organizations.

McKay married Olive Spencer in Minnesota in 1906, and their sons reflected his success. Duncan L. McKay, born in July 1907, graduated from Bend High School in 1926 and earned a law degree at the University of Oregon. He served as a major in the US Army during World War II before returning to Bend with his wife and setting up his own law practice. He died in June 1979. Gordon W. McKay, born in March 1910, graduated from Bend High School in 1929, attended the University of Oregon, served as a warrant officer in the US Navy during World War II, and worked around the West in engineering and real estate. In 1950, he and his young family returned to Bend, where he joined his father in the Deschutes Title and Abstract Company. In 1965, he began two terms as a state senator.

Clyde McKay, after a lifetime of promoting Bend's growth, died there in June 1954. (Courtesy of Deschutes County Historical Society.)

Levi D. Wiest, First City Engineer

Levi D. Wiest, a civil engineer and surveyor, arrived in Farewell Bend in the summer of 1900 from Portland, Oregon, to help Alexander M. Drake found Bend. Wiest platted the original Bend town site. He filed on a 160-acre homestead, and his family followed in 1901. He was the irrigation engineer for Drake's Pilot Butte Development Company, and his property was the first land to receive water from the new irrigation company in 1904. Bend was incorporated in 1905, and Wiest became one of the city's first subdividers; even before he occupied his own impressive three-story residence, other houses dotted his large Wiestoria Addition.

Wiest was born in January 1859 in Pennsylvania, graduated from Pennsylvania College in 1883, and married Flora Ellen Shunk in 1885. The couple moved from Pennsylvania to Nebraska, then westward with their growing family. Along the way, they survived an upset stagecoach, an upset wagon, Indians, railroad builders, and Oklahoma Land Rush participants. Just before the turn of the 20th century, they arrived in Portland, where Wiest worked for a railroad as a civil engineer. There, he met Drake and soon moved to the Bend area to work with him. He was instrumental in Bend's development for two decades. The Wiests were charter members of the First Presbyterian Church, Bend's first organized church.

Adventure called, and in June 1920 the Wiests left Bend on an auto trip that took them 13,100 miles through 28 states from 9,000 feet above sea level to 250 feet below—no mean feat in the early days of automobile travel—before returning to Bend in April 1921. Wiest had a sense of humor. "Few people outside the family can remember ever seeing Mr. Wiest without a full beard," Ila Grant Hopper wrote in the *Bend Bulletin* on October 14, 1967. "A few years before his death [in 1934] he shaved it off without telling the family, and posed as a relative from Pennsylvania, fooling even his wife." (Courtesy of Deschutes County Historical Society.)

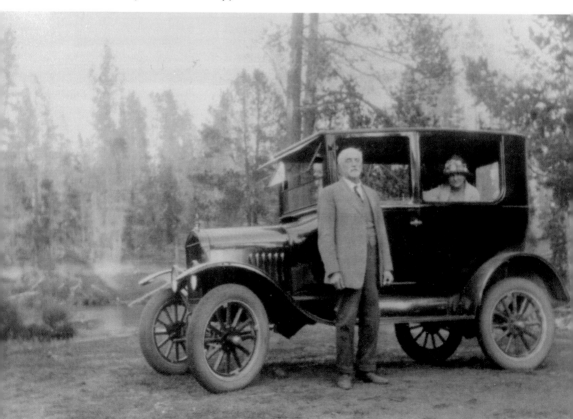

Hugh O'Kane, Early Developer

Born in County Antrim, Ireland, in 1853, Hugh O'Kane stowed away on a New York–bound ship. By the time he was 12, he was selling newspapers and shining shoes on the streets of New York City. He went west and worked as a tailor, sailor, miner, stagecoach driver, dispatch rider, horse trainer, and mule packer.

O'Kane married in Montana in 1895. In 1903, he moved to Bend, where he built and operated the popular Bend Hotel, which burned to the ground in August 1915. In its place, O'Kane built Bend's largest downtown commercial building; the O'Kane Building opened in 1916 with six retail stores, 20 offices, and a theater. A 300-pound fixture at his hotel, he regaled visitors with colorful stories. Late in life, he moved to Portland, where he died in 1930. (Both photographs courtesy of Deschutes County Historical Society.)

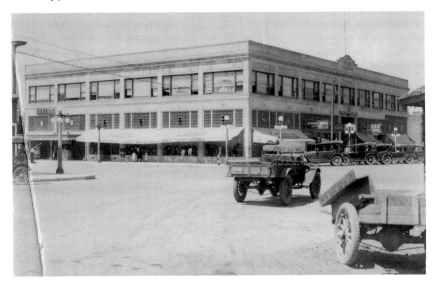

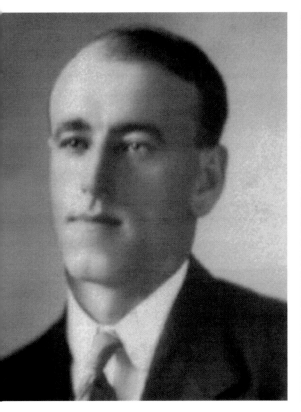 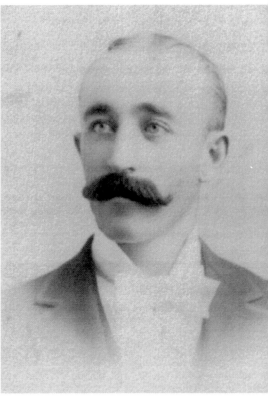

Ed and George Brosterhous, Early Builders

Ed (left) and George (right) Brosterhous, brothers who arrived in Bend in 1903, built many of Bend's early landmark buildings. Among these were the jail; many residences; the Reid School, completed in 1914; Kenwood School, which opened in 1919; St. Francis Catholic Church, completed in 1920; and Bend High School, which opened in 1926.

George Brosterhous, however, was killed during the spring of 1914, when he fell from the roof to the ground floor during construction of the Reid School building; death was instantaneous. Men were working on the roof near him, but none saw him fall.

And so it was Ed Brosterhous who made the brothers' name as general contractors. Born in 1879 in Winona, Minnesota, he and his wife, Cora, moved from Bend to Klamath Falls, Oregon, in 1928. In 1950, they relocated to Escondido, California, where he died in 1968. (Both photographs courtesy of Deschutes County Historical Society.)

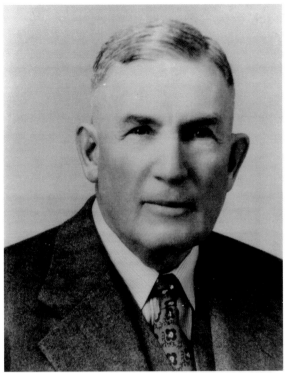

Harry A. and William E. Miller, Lumber Retailers

Harry A. "Ham" Miller (above), who came to Bend from Wisconsin, was one of three pioneering associates who founded the Overturf, Davis, Miller Company in 1911. Within two years, Ham bought out his partners and founded the multi-store lumber retail establishment, which was Central Oregon's largest building supplier in the 1960s and garnered the Bend Chamber of Commerce Business of the Year award in 2006.

Miller Lumber began by contracting the entire cut of a mill southeast of Bend and hauling the lumber back to be planed and retailed locally or wholesaled throughout the country. In 1915, the company sold the planning mill and adopted the retail lumberyard business. After college and World War II service as a naval aviator, son Bill Miller (below) joined the business. Today, the family-owned Miller Lumber Company operates retail lumberyards in Prineville, Madras, and Redmond, as well as Bend. (Both photographs courtesy of Miller Lumber Company.)

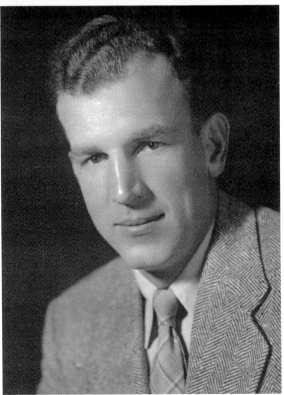

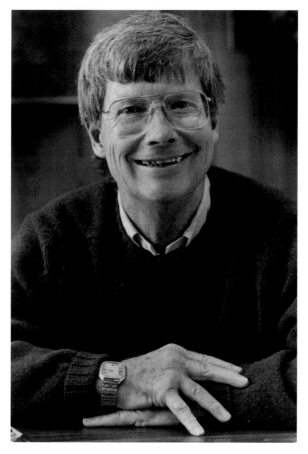

Bill Healy, Mount Bachelor Founder and Developer

It all started back in the 1950s when Bill Healy and a few of his Skyline Ski Club friends in Bend began to dream about building a ski area on what was then called Bachelor Butte, west of town on the Deschutes National Forest.

A Portland native who moved to Bend after World War II service in the US Army's 10th Mountain Division of rugged ski troopers, Healy was managing his father's Central Oregon furniture stores. He and a small group of other believers, including US Forest Service forester Don Peters, set out to convince community and government leaders that Bachelor Butte could become a ski area and an economic boon to the city, which then had fewer than 12,000 residents. At first, few shared their vision and confidence, but they forged ahead.

Healy and four other investors raised $75,000 to start the project and, in 1958 with Peters' help, convinced the Forest Service to permit a ski operation on the butte. A total of 822 skiers showed up for the ski area's first full weekend of operation in late December 1958. A story in the *Bend Bulletin* on the following Monday reported that skiers had come from as far away as Seattle.

Healy and other early supporters were proven right in the 1960s and 1970s as skiers from throughout the Northwest came to Bend's renamed Mount Bachelor. As the ski area grew and was joined by golf courses and resorts, Bend and Central Oregon grew into a year-round visitor destination. For 30 years, Healy presided over what became—and remains—Oregon's largest winter sports complex. A world-class ski resort, Mount Bachelor is the scene of Olympic ski training and national competitions.

Sidelined by a debilitating neuromuscular disease in 1988, Healy remained enthusiastically involved in the area's development and operation until he died in 1993 at age 69. (Courtesy of Deschutes County Historical Society.)

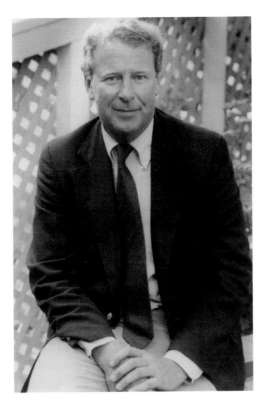

Michael P. Hollern, Visionary Developer

Michael P. "Mike" Hollern arrived in Bend in 1965, when he joined the Brooks-Scanlon Corporation as administrative manager. He spent the next five decades as a leading Central Oregon developer, whose vision is reflected in Bend today.

Hollern was born in Minneapolis, Minnesota, in 1938. Although his mother was a Brooks of the Brooks-Scanlon Corporation—owner-operator of one of Bend's two large lumber mills—he did not join the family business immediately after he graduated from college. He wanted to prove himself and took a television announcer job in Billings, Montana. After a year, during which he decided he was "no Chet Huntley or David Brinkley," he and his young wife moved to California, where he earned an MBA at Stanford University and served there as assistant to the vice president of finance for a couple years. In 1965, he joined his family's Minnesota-based company and moved to Bend as administrative manager of its Central Oregon timber operations.

The timber industry had faced hard times. Brooks-Scanlon soon recognized a future "not just in the timber business, but in the land business" and, in 1969, established the land development subsidiary named Brooks Resources Corporation of which Hollern became a visionary leader and ultimately chairman of the board and chief executive officer. Black Butte Ranch was Brooks Resources' first development. Mount Bachelor Village, Awbrey Butte, Awbrey Glenn, Northwest Crossing (jointly with Tennant Family Limited Partnership), and the Shevlin Riverfront industrial park followed under his leadership. He also helped bring roundabouts to Bend's growing road system. Hollern credits "paying attention to the land and culture" as a key to the environmentally friendly development.

Hollern and the corporation he leads are not only premier Central Oregon developers but generous and enlightened philanthropists who donated land for The High Desert Museum (south of Bend) and continue to support that fine institution and other area causes. Hollern received the 2014 Glenn L. Jackson Leadership Award from the Atkinson Graduate School of Management at Willamette University, which recognizes extraordinary entrepreneurial and civic leadership benefitting the state of Oregon. (Courtesy of Deschutes County Historical Society.)

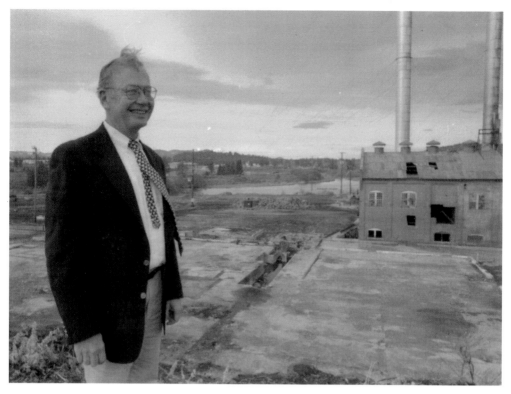

William Lee Smith, Visionary Developer

William Lee "Bill" Smith arrived in Bend in 1969 at age 29. Along with many new residents during the previous half-century or so, he went to work for the Brooks-Scanlon Company's sawmill. Unlike those others, Smith wound up owning the place, developing it into the Old Mill District and turning the abandoned heart of Bend's timber economy of the past into a vital part of Bend's diversified economy of the future.

"The most memorable event in Bend's history," in Smith's opinion, "was when the mills ran out of timber." By the 1990s, as a result of federal forest management policy changes that reduced availability of the Deschutes National Forest timber that had sustained the mills since the 1920s, the last mill was closed. "With both sawmills closed, Bend was left with a wonderful asset: the river running through this property. The town grew up around the saw mill[s], so we [were] looking at empty land in the middle of town with a river running through it, but no way to get there."

Smith found a way. With a vision of accessibility for the river, he saw a unique opportunity to create something special on that land. As president of William Smith Properties, Smith bought about 270 strategic acres of that land just southwest of downtown. After more than five years of planning, he and his development partners restored and redeveloped the riverbanks. They turned three of the original Brooks-Scanlon mill buildings into a visual centerpiece for their "new" Old Mill District. Three prominent 1923 structures—the fuel building, the powerhouse building, and the electric shop—comprise the Old Mill District's "powerhouse complex," with its three distinctive smokestacks. Around this complex, which honors the site's history, are shops, galleries, and restaurants with more than 2,000 employees and tens of thousands of visitors throughout the year. Across the river is the Les Schwab Amphitheater, a major entertainment venue.

"Some people focus on the negative aspects of Bend's growth," Smith explains, "But it's hard to deny the ways in which growth has contributed to the quality of life in Central Oregon. When I moved to Bend in 1969, the chances of my kids finding a job here were zero. Now, here they are, both working in Bend." (Courtesy of Deschutes County Historical Society.)

CHAPTER THREE

Politicians and Public Servants

"We the People of the United States" elect politicians to make laws that are carried out by public servants, who, in turn, provide community services and accomplish societal objectives. The people of Bend, and all other citizens of the United States, elect politicians not only to city but county, state, and national legislative bodies who support and provide for these public services. The few legendary locals profiled in this chapter—along with hundreds of others—represent these politicians and public servants.

Bend, incorporated in 1905 as a city within Crook County, Oregon, assumed responsibilities for its residents previously of the county government based in Prineville. The citizens elected a city council, which provided for public safety—law enforcement and fire protection—as well as public works and other city needs. In 1916, when the people of a growing Bend carved Deschutes County out of Crook County, residents established a new county government, seated in Bend, and elected county commissioners, a county sheriff, and other county officials who appointed public servants.

A broad range of community services, provided by neither city nor county governments, is provided by special service districts established pursuant to Oregon state law. School districts are one form of these; public schools in Bend are operated not by the city but by Bend-La Pine Schools, which operates schools within the district. The Bend Parks and Recreation District is another noticeable district. Others include irrigation districts, rural fire protection districts, and soil and water conservation districts. Like other government bodies, each district has the power to tax property inside its boundaries to finance the services it provides. Each is directed by a governing body elected by the voters.

Residents of Bend vote on who will represent their districts in the state legislature; they also elect a congressperson to represent Oregon's Second Congressional District in the US House of Representatives, two senators to represent Oregon in the US Senate, and the president and vice president of the United States. State and federal government agencies have offices in Bend that are staffed by public servants; the headquarters of the Deschutes National Forest, from which a vast 1.6-million-acre national forest is administered, is an example.

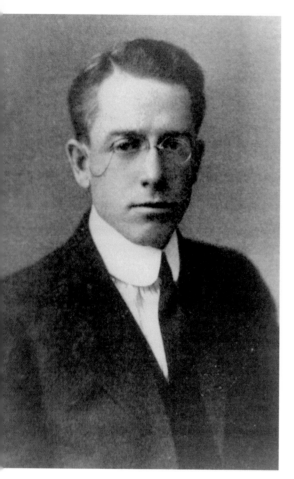 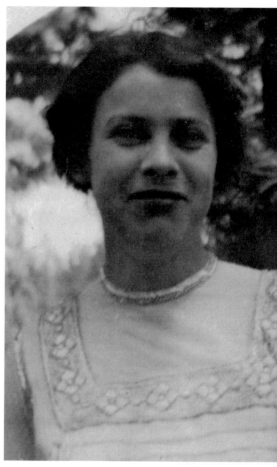

Vernon A. and Ann Markel Forbes, Early Power Couple

Vernon A. Forbes, born in October 1883 in St. Croix Falls, Wisconsin, arrived in Bend in 1910, following his graduation from the University of Minnesota Law School. He took an active part in Bend's political and social life and was elected to Oregon's House of Representatives from Crook County in 1912 and 1914 and from newly defined Deschutes County in 1916.

Ann Markel, who arrived in Bend in 1909, was a schoolteacher. She married Forbes in April 1914, and they had one son. On July 7, 1918, Forbes and another fisherman drowned in Crescent Lake. Markel remained in Bend, where she raised their son, Vernon; operated a gift shop and a real estate business; was active in the Presbyterian Church, American Legion Auxiliary, and the Red Cross; and traveled extensively in North America and Europe. (Both photographs courtesy of Deschutes County Historical Society.)

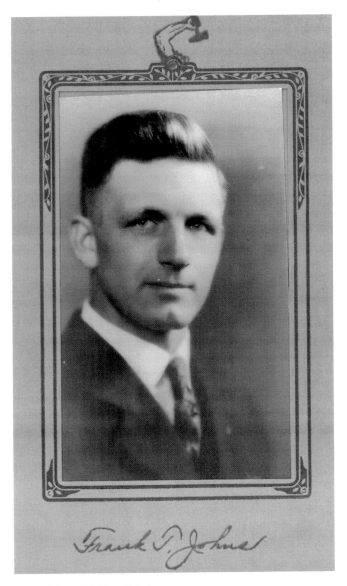

Frank T. Johns

Frank T. Johns, Presidential Candidate

Frank T. Johns was not a Bend local, but a tragic 1928 attempt to save the life of a drowning local boy named Jack C. Rhodes made him a local legend. Oregonian and Socialist Labor Party presidential candidate in 1924 and 1928, Johns was born in Pennsylvania in 1889. He moved to Portland as a young man and worked as a carpenter. He and his wife had three children, two of whom lived to adulthood. Johns was an advocate for strong industrial unions and the rights of the working class—political beliefs that led him to the Socialist Labor Party. After organizing the party's Oregon contingent, he was nominated by the national party as its presidential candidate in both 1924 and 1928.

Not long after receiving the 1928 presidential nomination, Johns made his first campaign stop at Drake Park in Bend. His speech was interrupted by cries for help from a drowning child in the nearby Deschutes River. Johns was 39 years old when he also drowned in an unsuccessful attempt to rescue young Jack Rhodes. His family was awarded a Carnegie Medal—and its accompanying endowment—for his heroic effort. (Courtesy of Deschutes County Historical Society).

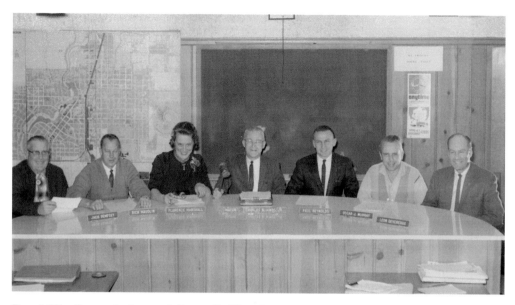

Bend City Commission and Council, City Governing Bodies

Bend City Commission members in 1966, from left to right, were Jack Dempsey, Dick Maudlin, Florence Marshall, Mayor Charles B. Hinds Jr., Paul Reynolds, Oscar J. Murray, and Leon Devereaux. They met in the Bend city hall of the time. From incorporation in 1905 until 1929, Bend was governed by an elected city council of three, who designated a mayor from among their number. In 1929, Bend changed to a city commissioner–manager form, with three—later seven—elected commissioners who appointed a city manager and designated a mayor from their own ranks. In 1994, Bend's new city charter changed the titles of the seven elected members from commissioner to councilor. They are elected to four-year terms, and elect a mayor from among themselves. The council appoints a city manager, while the mayor conducts council meetings and serves as an ambassador for the city. (Both photographs courtesy of Deschutes County Historical Society.)

Ruth Burleigh, City Commissioner and Mayor

A descendant of Oregon pioneers—her great-grandfather and his brothers arrived in the Willamette Valley by wagon train in 1846—Ruth Burleigh was born in Marshfield, Oregon, where she attended small country schools until her family moved to Eugene. After she graduated from Eugene High School, attended the University of Oregon, and completed a year of medical technology training at Good Samaritan Hospital in Portland, she arrived in Bend in 1946. Burleigh came to Bend for a job at St. Charles Hospital. "I was the only person in the laboratory and I began a career which lasted 45 years and, by that time, the lab had grown to 85 employees," she recalled in January 2014.

Two years after she arrived in Bend she married Van Burleigh, and they had three sons. A few years before he died in 1977, she helped start the Bend chapter of the League of Women Voters and became interested in city government. In July 1974, she was appointed to fill a vacancy on the Bend City Commission, on which she served until the end of December 1986. During those busy years, she was twice elected as mayor, and Bend built its first real sewer system. In 1984, she was elected president of the League of Oregon Cities and worked with many people from all around the state.

Burleigh's busy civic life has also involved work with the Deschutes County Public Library, Hospice, Central Oregon Symphony, Deschutes County Historical Society, Family Kitchen, Bend Boys and Girls Club, and other organizations. She is an active member of the Nativity Lutheran Church and was the Deschutes Pioneers Association "Pioneer Queen" in 2013. (Courtesy of Bend Pioneers Association.)

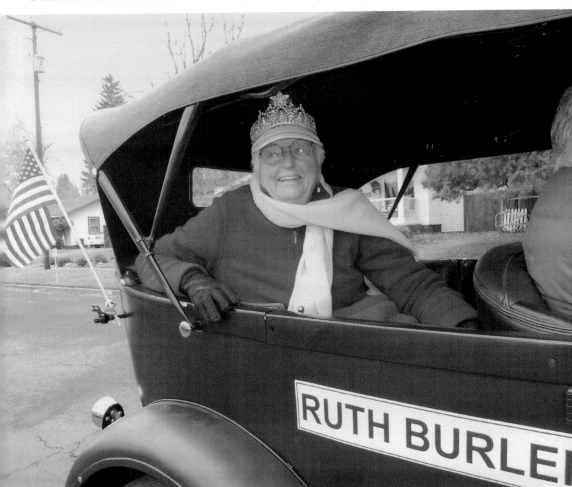

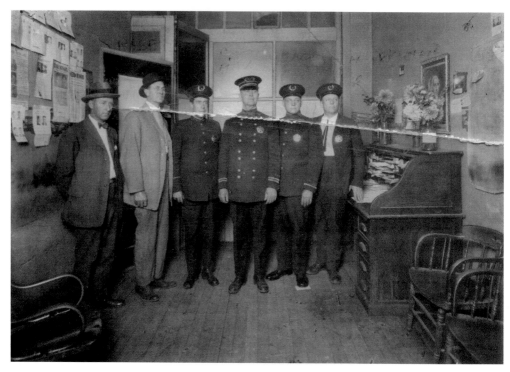

Bend Police Department
A city marshal policed Bend from 1905 until 1911, when the Bend Police Department was established. S.E. "Bert" Roberts—first Bend police chief and first Deschutes County sheriff—and L.A.W. Nixon preceded Chief P.J. "Pete" Hanson (fourth from left), who was followed by chiefs P.A. Thomas and K.C. McCormack. (Courtesy of Deschutes County Historical Society.)

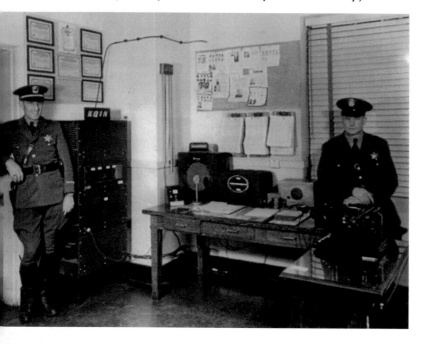

Jack Rambo, Police Chief
The radio room was the Bend Police Department's nerve center by the time J.E. "Jack" Rambo (left) served as chief of police from 1937 to 1942. (Courtesy of Deschutes County Historical Society.)

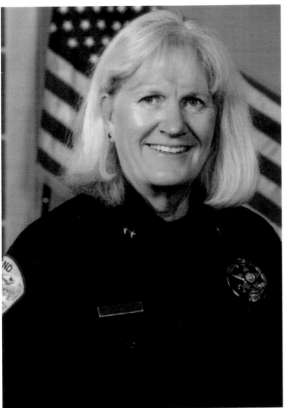

Sandi Baxter, Police Chief
A 1974 graduate of Bend High School, Sandi Baxter joined the Bend Police Department as a reserve officer in 1977, became a full-time officer in 1979, and retired in late 2007. Bend's first female police officer, she returned to the force in April 2008 to serve as the city's first female police chief through June 30, 2011. (Courtesy of Bend Police Department.)

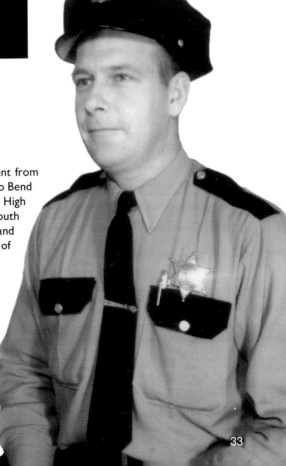

Emil K. Moen, Police Chief
Chief Emil K. Moen led the Bend Police Department from 1963 to 1978. Born in Bimiji, Minnesota, he moved to Bend with his parents at age five, graduated from Bend High School in 1939, and served in the US Army in the South Pacific during World War II. He returned to Bend and joined the police department in 1945. (Courtesy of Deschutes County Historical Society.)

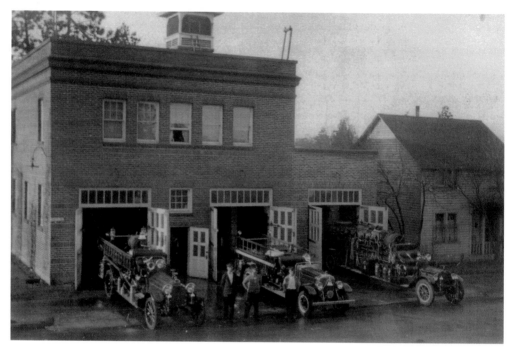

Bend Fire Department

On April 27, 1905, Bend's first major fire destroyed the O'Kane Saloon at the corner of Bond and Oregon Streets. Volunteers battled the blaze with wet blankets and saved the wooden buildings of the downtown business district. Later in 1905, the newly incorporated city installed its first fire protection system of street hydrants and hose carts.

More fires during the next dozen or so years took their toll. Forest Ranger John Riis recalled that he and Ranger Harold E. Smith, in town at Deschutes National Forest headquarters, were awakened on the night of February 6, 1913, by "the fire bell clanging." They helped fight a fire that "started in a saloon in the First National Bank block and finally burned the whole block clean from the bank building up to the corner of [the livery] barn nearest the depot. The bank building wasn't hurt any. There were four hose pipes playing on the flames but the wind was too strong to prevent the fire from running its course."

Six years later, on February 24, 1919, the city council formed the Bend Fire Department. Thomas W. Carlon, the first chief, served until his death in November 1943. In 1919, he received the department's first motorized fire apparatus, an American LaFrance pumper and, a year later, moved into the city's first fire station, at the corner of Lava Road and Minnesota Avenue. The first test of the new fire department and its pumper came on July 6, 1920, when five downtown structures burned. The department performed admirably and saved the rest of the downtown business district.

Under Chief Carlon's leadership, the Bend Fire Department earned national recognition as a superior fire department. Other chiefs followed in his footsteps, including his son Vern Carlon, who served as chief from 1952 to 1973. Today's Bend Fire Department comprises some 80 personnel—cross-trained to provide firefighting and emergency medical services—who staff 13 pieces of firefighting equipment and seven ambulances based at five fire stations. The department serves a city of 80,000 and a rural fire protection district, also providing advanced life-support emergency medical services to an area larger than the state of Rhode Island. Because of improvement in construction and fire prevention, over 80 percent of the department's emergency responses are calls for medical aid. (Courtesy of Deschutes County Historical Society.)

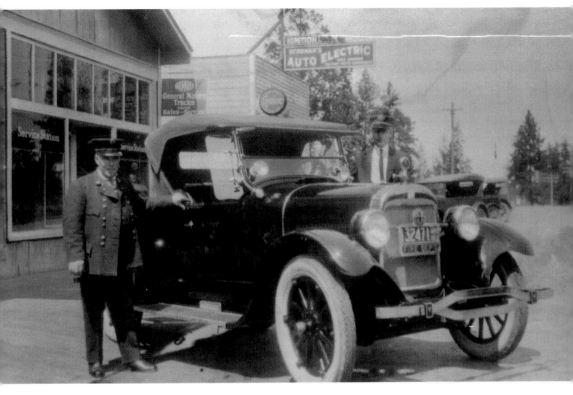

Tom Carlon, First Fire Chief
Born in Roseburg, Oregon, Tom Carlon moved to Bend from Portland, Oregon, in 1916, and served as Bend's first fire chief from 1919 until he died in 1943. He built a modern fire department during his 34-year administration. His son Vern Carlon joined the fire department in 1934 and became Bend's third fire chief in June 1952. He retired on the last day of 1973 and died in December 1995. (Courtesy of Deschutes County Historical Society.)

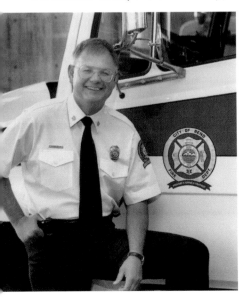

Larry Langston, Fifth Fire Chief
Born in 1944, Larry Langston studied biology at the University of Colorado, became a teacher, and changed careers in 1972. At age 38, he became the youngest fire chief of Anchorage, Alaska. After 22 years in the Alaskan fire service, he moved to Bend in 1994 and served as chief of Bend Fire and Rescue for 14 years, during which he oversaw expansion of fire stations, fire apparatus and equipment, and staffing for the rapidly growing city. (Courtesy of Deschutes County Historical Society.)

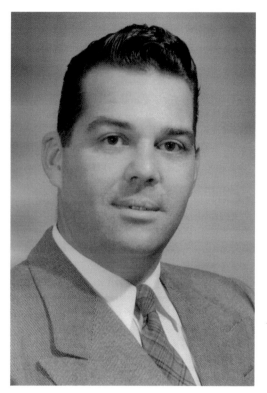

Poe Sholes, County Sheriff
Bend native F.C. "Poe" Sholes returned to his hometown in 1946 from World War II service in the US Marine Corps to serve three years as a Bend Police Department officer and then became a Deschutes County Sheriff's Office deputy. Sheriff Claude McCauley decided to retire in 1953 and encouraged Sholes, by then a deputy, to run for the office. He did, won, and served as Deschutes County's third sheriff for 28 years. (Courtesy of Lennard Sholes.)

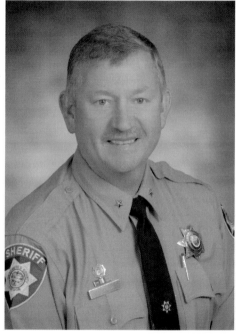

Larry Blanton, County Sheriff
Larry Blanton, who began his law enforcement career in 1976, joined the Deschutes County Sheriff's Office in 1985 and rose through the ranks to lieutenant. Appointed undersheriff by Sheriff Les Stiles in 2000, he led the campaign for permanent funding of the sheriff's office which Deschutes County voters approved in 2006. He was appointed by Deschutes County commissioners to succeed retiring Sheriff Stiles in 2007, won reelection in 2008 and 2012, and retired in 2015. (Courtesy of Deschutes County Sheriff's Office.)

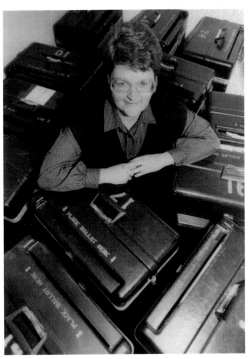

Susie Penhollow, County Clerk
Conducting elections is one of the main jobs Susie Penhollow (shown surrounded by ballot boxes) did as Deschutes county clerk. Born and raised in Bend, she began her career in the county clerk's office in 1970 as a deputy clerk. She was elected county clerk in 1982 and was reelected to four more terms before she retired in 2002. Penhollow later supervised and observed elections in several Eastern European countries. (Courtesy of Deschutes County Historical Society.)

Barry Slaughter, County Commissioner
Born in Connecticut in 1933, Barry Slaughter served in the US Marine Corps and graduated from Whittenburg University in Ohio before he eventually moved to Bend from Los Angeles in 1975. He was manager of the Arnold Irrigation District in Bend for six years and was elected a Deschutes County commissioner in 1992. Seriously injured in a 1993 accident, he continued to serve the community until he died in 2001. (Courtesy of Deschutes County Historical Society.)

William A. Niskanen, Economist

William Arthur Niskanen, born in Bend in 1933, was the first Bend High School graduate to go to Harvard University. He became a nationally known economist and an architect of Pres. Ronald Reagan's economic program. Niskanen received a bachelor of arts degree from Harvard in 1954. Graduate study in economics at the University of Chicago led to a master's degree in 1955 and a doctorate in 1962. His teachers included Milton Friedman and other economists who were then revolutionizing economics, public policy, and law; Niskanen became one of them.

While a graduate student, Niskanen joined the RAND Corporation as a defense policy analyst. His work caught the attention of the incoming Kennedy administration, which appointed him director of special studies in the Office of the Secretary of Defense, where he was one of Defense Secretary Robert S. McNamara's original Pentagon "whiz kids." In 1964, Niskanen became director of the Program Analysis Division at the Institute for Defense Analysis, and in 1972, he served briefly as assistant director of the Office of Management and Budget before leaving Washington to be a professor of economics at the University of California at Berkeley. There, he helped establish the graduate school of public policy and served on then governor Ronald Reagan's task force on California's economy.

Niskanen was Ford Motor Company's chief economist from 1975 until 1980, when he was dismissed for criticizing the company's corporate culture and commercial policies. He returned to academia, this time at UCLA, but soon joined incoming President Reagan as a chairman of his Council of Economic Advisors until his criticism of the administration's tax policies resulted in his resignation in 1985. Niskanen then joined the Cato Institute, where he was chairman of the board of directors and a policy scholar until 2008. He was chairman emeritus until he died in Washington at age 78 in 2011.

Bend High School graduate Niskanen made contributions to economics and public policy represented in many articles, essays, and books including *Bureaucracy and Representative Government* (1971), *Bureaucracy and Public Economics* (1994), *Reaganomics* (1988), *and Reflections of a Political Economist* (2008). According to his *New York Times* obituary, Niskanen praised President Reagan for his vision and charisma but lamented that, as president, he had been unable to curtail federal spending. "In the end," he wrote, "there was no Reagan revolution." (Courtesy of Deschutes County Historical Society.)

CHAPTER FOUR

Business Professionals and Entrepreneurs

At the dawn of the 20th century, Bend's business community comprised a few merchants dealing in such basic commodities as groceries and dry goods, a banker or two, a few blacksmiths, operators of livery stables, real estate and land agents, farmland and timberland speculators, and purveyors of spirits and pleasures. A small newspaper served a town approaching 300 souls. Irrigation was booming. Just over 100 years of business entrepreneurship later, early in the 21st century, some who should know see the diverse and dynamic business community of the city of 80,000 as possibly "the most eclectic—and fastest-growing—of any similarly sized city in America."

In his 1939 book, *Frontier Doctor*, physician Urling C. Coe described a 1905 Bend street scene that recalls an early socioeconomic milieu, starkly different from that of today:

> Freighters, stockmen, buckaroos, sheep herders, timber cruisers, gamblers, and transients of all kinds who had been attracted to the town by the boom, thronged the bars or played at the gambling games, and the stores were doing a rushing business. The stores remained open in the evenings, and the saloons remained open all night and all day Sunday, and many of the laborers from the construction camps spent the weekends in town, drinking, gambling, carousing, and fighting.

James M. Lawrence, a legendary local not individually profiled, had a hand in much of this early action. Appointed US Land Commissioner in Bend in 1903, he coordinated homestead and other public land claims and business for the General Land Office of the US Department of the Interior. A newspaperman, he bought the weekly *Bend Bulletin*—founded in 1903 by first publisher Max Lueddemann and edited by Don P. Rea—in 1904 and moved it from a cabin on the east bank of the Deschutes River to a downtown office. Transferred to the Roseburg, Oregon, land office in 1906, he returned to Bend in 1910, sold the newspaper to George Palmer Putnam, developed an insurance and loan business, and served as secretary of the First National Bank.

Arrival of the Oregon Trunk Railroad in 1911 fueled growth of a more vibrant business community. The tenfold growth of Bend's population by 1920—a result of the timber economy—attracted entrepreneurs, who eventually grew and diversified the city's economy. Development of Mount Bachelor as a ski area, started in the late 1950s by legendary local Bill Healy and skiing friends, proved the catalyst for Bend's visitor industry, economic growth, and diversification. In his footsteps, other entrepreneurs evolved the modern business community, responsible for the many beautiful residential areas and vibrant shopping, dining, and entertainment venues that define Bend life today for residents and visitors alike.

In publication since its 1903 founding, the *Bulletin* has benefitted from a succession of distinguished publishers, editors, and journalistic entrepreneurs who have told and continue to tell Bend's story of growth.

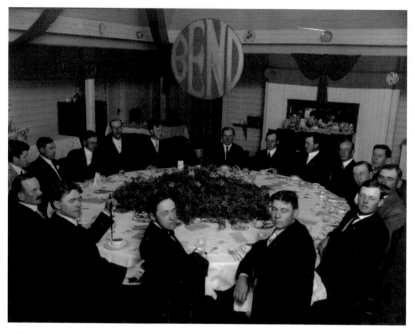

Emblem Club, Early Bend Boosters

The Emblem Club, apparent forerunner of the Bend Chamber of Commerce, was an ambitious but short-lived booster organization begun in 1912 by W.D. Cheney of Seattle, Washington, a heavy investor in and enthusiastic promoter of Bend's commercial possibilities.

The founder and members gathered for dinner on the evening of January 4, 1913. Among them, in addition to Cheney, were *Bend Bulletin* owner and editor George Palmer Putnam and Clyde McKay. Cheney expressed high hopes for a club of "character" and "honest, human manhood" which, "working as an absolute unit . . . could make a Governor of Oregon" or "seat a President of the United States." The club's insignia, hanging over the table, is incorporated into the current Bend logo, which stands for a modern city of 80,000.

Many of those Emblem Club worthies staged a fake train robbery as a publicity stunt. (Both photographs courtesy of Deschutes County Historical Society.)

Nickolas P. Smith, Merchant

Nickolas P. Smith opened N.P. Smith Builders Supplies on Wall Street as 1909 became 1910. Business was conducted on the first floor, and the family—Smith, his wife, Corabell, their sons, Elmer and Lester, and their daughter, Marjorie—lived on the second floor. Born on September 14, 1909, Marjorie Smith was the first baby born in Bend's first hospital. (Courtesy of Deschutes County Historical Society.)

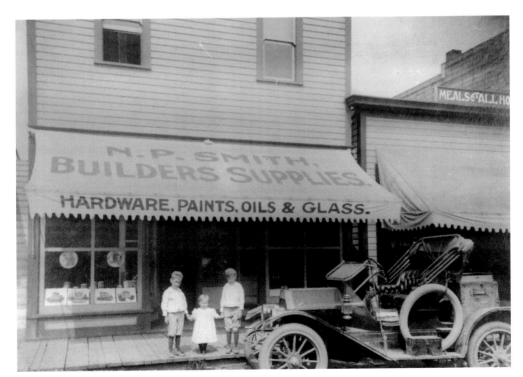

Marjorie Smith, Witness to History

From the time she was born until she turned 94—except when away at college or traveling—Marjorie Smith, shown flanked by her brothers about 1912, was an eyewitness to Bend's history. From the window of the family's—later her—second-floor residence, she watched Bend grow from less than 1,000 souls to about 80,000 when she died at age 100 in 2010. Smith left the historic building to the Deschutes County Historical Society. (Courtesy of Deschutes County Historical Society.)

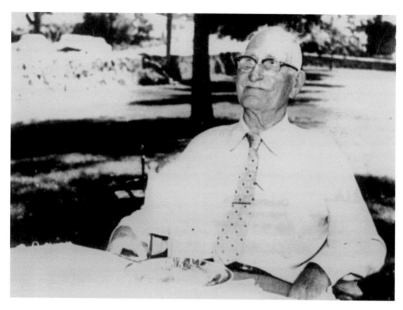

Evan A. Sather, Merchant

Evan A. Sather and his family arrived in Central Oregon by covered wagon in 1902. Born in Norway in 1860, Sather immigrated to the United States at the age of 20, settled in Minneapolis, Minnesota, where he married Christina Peterson in 1886, and moved west to Tacoma, Washington. In 1904, after he and his family settled in Bend, Sather opened a general merchandise business on Wall Street. For many years, Sather's Hall, on the building's upper floor, was used for lodge meetings, dances, and other gatherings. Sather served on county election boards for many years after he retired from business in 1917. Frequently cited as one of Bend's oldest pioneers, Sather attended the Deschutes Pioneers Association annual picnic when he was 99 years old. A resident of Bend for 58 years, he died at his 7 Tumalo Avenue home at 102 years of age. (Both photographs courtesy of Deschutes County Historical Society.)

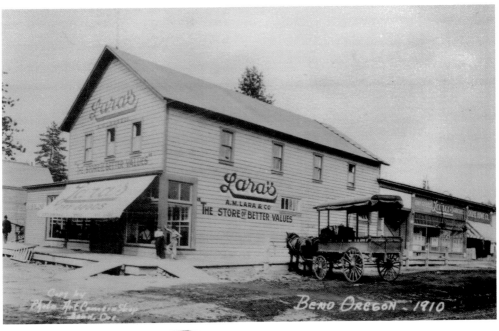

Arthur M. Lara, Merchant

Arthur M. Lara arrived in Bend from Minneapolis, Minnesota, in December 1907. Lara purchased the Bend Mercantile Company store on the northeastern corner of Wall Street and Oregon Avenue. Within a few years, Lara established Lara's Store, "The Store of Better Values," the first department store in Bend and Crook County. As reported in the *Bend Bulletin* on Wednesday, September 7, 1910, "Lara's rebuilt and rearranged store was officially and formally opened last Saturday" and "thronged with people most of the day" as "the store enjoyed its best day of trade for months." Lara built a large residence at 640 Congress Street, which is still known as the Lara House. Lara's business failed in 1913, and Lara and his family moved to the Oregon Coast. (Both photographs courtesy of Deschutes County Historical Society.)

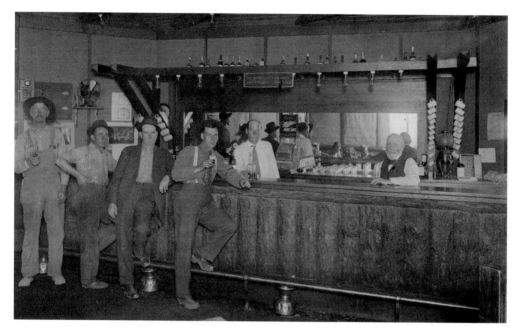

Michael P. McGrath, Saloon Keeper

Michael P. "Mike" McGrath (on the left behind the bar) was born in Ireland in 1846. At age 63, he sailed for the United States and arrived in Bend in 1909. He engaged in early irrigation system construction but made his name when he briefly owned and operated the Log Cabin Saloon on the corner of Bond Street and Oregon Avenue. The saloon was housed in the log cabin behind Albert Taylor in his bear coat and his son Sylvester on a horse, where McGrath held forth at the bar. He sold out when the 18th Amendment to the US Constitution prohibited the sale of alcoholic beverages. When he left Ireland, McGrath left his wife, Stacia, and their 11 children forever. He did, however, send money to his wife for the rest of his life. He died in Bend in 1926 at the age of 80. (Both photographs courtesy of Deschutes County Historical Society.)

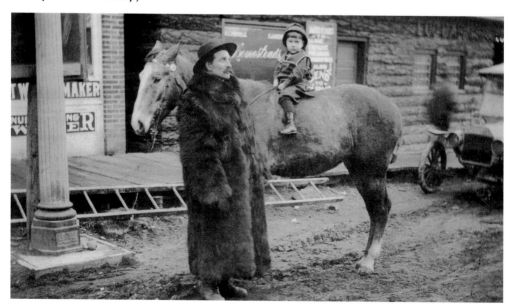

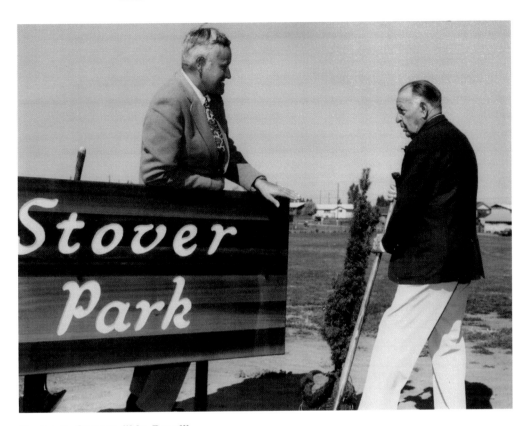

Byron A. Stover, "Mr. Bend"

Governor Tom McCall (left) and Byron A. "Dutch" Stover (right) did the spadework at the September 23, 1971, dedication of Dutch Stover Park, named in honor of Stover's decades of service to Bend, Oregon, and the United States.

A 1913 forestry graduate of and two-year football letterman at Ohio State University, Stover arrived in Bend in 1914. He applied for a position with the Bend Company to be operator of an early Bend sawmill. "We have no *positions*, but if you want a *job*, come along!" the company replied. He did and worked at the old Bend Company mill on the west bank of the Deschutes River. He soon moved to a bank teller position at the First National Bank. World War I called, and as a second lieutenant in the US Army, Stover served with the mounted field artillery in France.

Six years after World War I ended, Stover returned to Bend to purchase—with some partners—the newly completed Capitol Theater on Wall Street, the almost adjacent Liberty Theater, and other Central Oregon theaters. He brought his wife, Ruth, to Bend in 1924. The couple "adopted" the youngsters of Bend and opened theater doors, often without charge. Win or lose, Bend's high school athletes were treated to movies. The free movies were always chosen by Stover as "proper for family entertainment." He remained in the theater business until 1926 and then pursued other businesses.

Stover's interest in athletics found expression in training football players. He learned the fundamentals of football while playing end at Ohio State and was a fine coach. He presented the annual Stover Award to outstanding Bend High School athletes. His friends set up the Dutch Stover Trust Fund to provide a yearly scholarship.

In addition to serving as director and president of the Bend Chamber of Commerce, Stover was an active member of many other civic and fraternal organizations. Beginning in 1949, he served several terms in Oregon's state legislature. Stover was, indeed, the "Mr. Bend: not the man of the year, but of the decades" of whom Phil Brogan wrote in the June 3, 1966, *Bulletin*. Stover retired from business in 1955 and died in 1984 at the age of 94. (Courtesy of Deschutes County Historical Society.)

Myrl P. Hoover, Transportation Pioneer

Mount Hood Stages driver Maurice Hoover (right), a brother and partner of the bus company's founder, lined up for this 1930s photograph with the Lady Elks Drill Team. Born in 1900, young Myrl P. Hoover arrived in Bend in 1912 and soon began a bus transportation service that became known as Mount Hood Stages, Inc. Truly an owner-operator, he tied his hometown to much of the rest of the state before his company was merged with Pacific Trailways during World War II.

In 1915, at the age of 15, Hoover began his career by driving a Model T Ford around Bend in his father's for-hire jitney service. A year later, he took over the jitney portion of his dad's business and upgraded to a 12-passenger Studebaker that also carried freight. By 1929, he was operating daily service from Bend to Shaniko to connect with Union Pacific Railroad trains. His family owned the Ford-Lincoln automobile dealership in Bend, and the building was remodeled to serve as depot, office, and garage for what by then was called Hoover Stages. In 1931, Hoover and another operator incorporated as Mount Hood Stages and were soon running busses from The Dalles to Klamath Falls, Portland to Bend, and Eugene to Bend; by 1934, from Bend to Burns; and a year later, from Bend to Lakeview and Ontario. In 1935, Mount Hood Stages added service from Portland to Boise.

Mount Hood Stages joined the National Trailways Bus System on January 1, 1943, and Pacific Trailways was formed; Mount Hood Stages, however, retained its corporate name. A 1945 strike by a competitor's drivers gained Pacific Trailways a route to Salt Lake City, Utah. As time passed, Bend bus transportation pioneer Hoover moved to California. As transportation systems evolved, the bus company evolved and eventually came under different management. "Mr. Hoover is dead at the age of 70," the *Bulletin* reported on May 29, 1970. "His story of success is one that will have a place in the ever-changing history of transportation in the west." (Courtesy of Deschutes County Historical Society.)

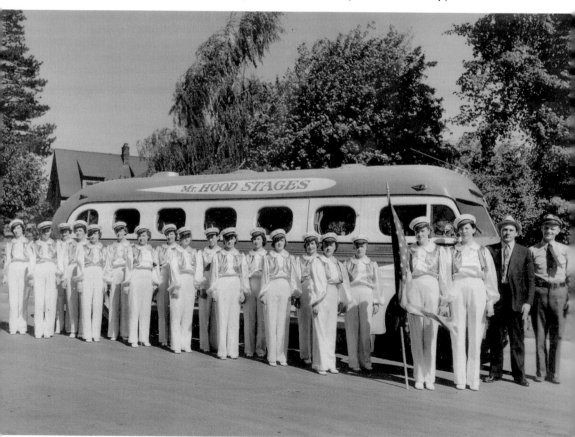

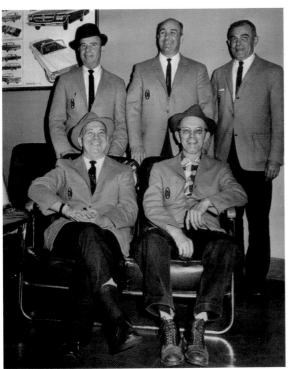

Edwin Walter Williamson, Automobile Dealer

Born on a homestead between Bend and Burns, Edwin Walter "Eddie" Williamson (front left) moved to Bend with his family in 1916. Williamson started working in service stations and bought his own station. In 1936, he purchased the stone garage on the corner of Wall Street and Greenwood Avenue, where he was the Chrysler dealer conducting business as Eddie's Sales and Service for the next 40 years. (Courtesy of Deschutes County Historical Society.)

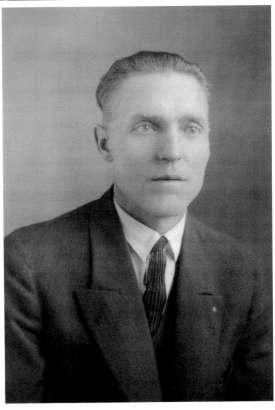

Wilmer Roy Van Vleet Sr., Photographer

Born in 1888 in Dodge, Wisconsin, Roy Van Vleet arrived in Bend and went to work for the Shevlin-Hixon Lumber Company in 1916. He served in the US Army during World War I, married a Prineville girl, and acquired and operated the Elite Studio, a portrait and commercial photographic studio in Bend, until 1929. Van Vleet left a legacy of magnificent photographs that document Bend and its surroundings during the early 20th century. (Courtesy of Deschutes County Historical Society.)

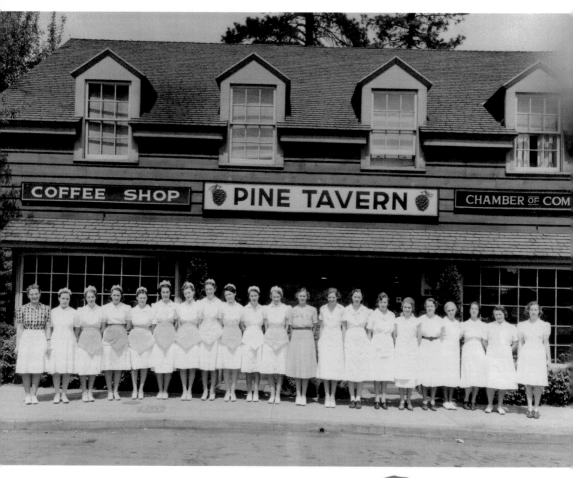

Maren Gribskov, Restauranteur

Back in 1936, when Maren Gribskov selected the name Pine Tavern for her new restaurant and coffee shop in downtown Bend, she could not have known it would become her city's most venerable eatery. The restaurant opened on December 19. Gribskov was no stranger to restaurants. She and Pine Tavern co-owner Eleanor Bechen's sister, Martha Bechen, had opened the OIC Cafeteria, Bend's first such establishment, in 1919. Born in Cozad, Nebraska, in 1894, Gribskov earned a degree in home economics at Oregon Agricultural College in 1918. During the Great Depression, the going at the Pine Tavern was nip-and-tuck for a while. But with good food, good service, and a friendly atmosphere, the business thrived. Gribskov and Bechen sold the Pine Tavern in 1967. Almost 50 years later, it remains among Bend's more popular restaurants. Gribskov died in 1984. (Both photographs courtesy of Deschutes County Historical Society.)

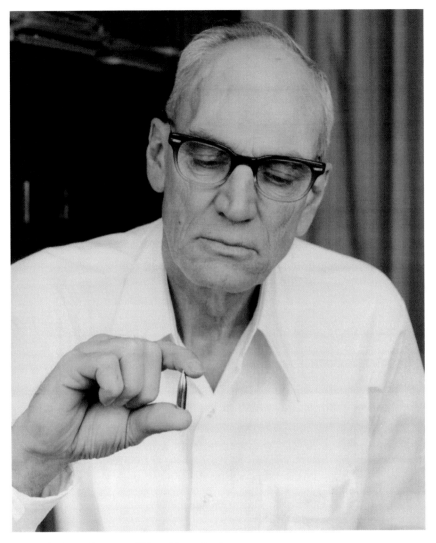

John Amos Nosler, Ammunition Manufacturer

John Amos Nosler, the founder of Bend's ammunition manufacturer, Nosler Incorporated, revolutionized big game hunting by developing a special bullet. Born in Brawley, California, in 1913, Nosler dropped out of high school after the 1929 Stock Market Crash and went to work at a Ford Motor Company factory. There, at age 19, he got the attention of Ford executives when he developed a new type of crankshaft eventually used by the company. He became known as an innovator.

Nosler's signature innovation resulted from a 1946 moose hunting trip in British Columbia. When the bullets he was using failed to kill quickly the animal he shot, he developed a controlled-expansion bullet that did. His new Nosler Partition bullet penetrated the target and expanded after impact for a quicker, surer kill. He began manufacturing and selling the bullet in 1948, and it remains the company's flagship product and the gold standard among premium hunting bullets. Another of his innovative bullet designs, the Nosler Ballistic Tip bullet, has been adopted by other manufacturers.

A massive explosion rocked the Nosler plant in Bend in June 2010, but nobody was harmed and the company quickly resumed production. John Nosler died in Bend in October 2010 at age 97, but his family-run company continues to make a variety of hunting bullets as well as limited edition and semi-custom hunting rifles. (Courtesy of Nosler Incorporated.)

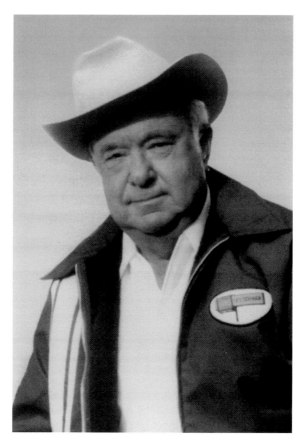

Les Schwab, Founder of Tire Empire

Leslie Bishop "Les" Schwab, born in Bend in 1917, overcame childhood hardships to found Les Schwab Tire Centers, which trade journal *Modern Tire Dealer* called "arguably the most respected independent tire store chain in the world." Two years after he was born, Les Schwab's parents moved their family to Minnesota. In 1929, they returned to Central Oregon, where Schwab attended the school at the Brooks-Scanlon logging camp at which his mother taught. Orphaned as a 15-year-old high school student, Schwab supported himself by delivering the *Oregon Journal* newspaper. He graduated from Bend High School in 1935, married high school sweetheart Dorothy Harlan in 1936, and fathered a son and daughter who both died before their parents. Schwab became circulation manager for the *Bend Bulletin* in 1942 and served in the US Army Air Forces during World War II.

Schwab plunged into the tire business at age 34 in 1952, when he borrowed money to purchase an OK Rubber Welders franchise store in nearby Prineville, Oregon, for $11,000. He knew nothing about tires, but knew how to work and increased the store's sales nearly fivefold in his first year of business. In 1953, he opened a second store in Redmond, Oregon and, in 1955, a third in Bend. He then dropped the franchise and named his business "Les Schwab Tire Centers" in 1956. Schwab built a billion-dollar tire empire that had 410 stores in the western United States and $1.6 billion in annual sales by 2007. His keys to success were employee loyalty and good service. "If we can't guarantee it, we won't sell it" was his company's motto. Despite its success, he refused to take the company public.

Schwab gave up day-to-day control of the company in the late 1980s. In the early 1990s, the Schwabs funded a local hospital expansion in honor of their son who died in 1971. Their daughter died in 2005. Schwab's health began to deteriorate that year, and he died in May 2007. His company's headquarters moved to Bend in 2008. The Les Schwab Amphitheater in Bend is named for him. (Courtesy of Deschutes County Historical Society.)

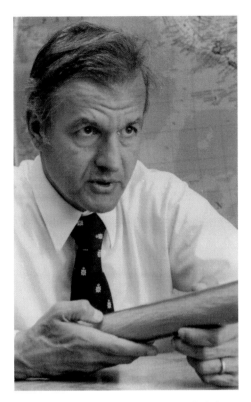

Harold K. Lonsdale, Scientist, Entrepreneur, and Politician

Harold K. "Harry" Lonsdale, born in 1932 on a New Jersey chicken ranch where he was raised, founded Bend Research, Inc. in 1975 and brought the high-tech research and development business as well as his own brand of politics to Central Oregon. He married Connie Kerr, his high school sweetheart, in 1953. They had two children and divorced in Bend in 1983. He remarried twice.

Lonsdale earned his bachelor of science degree and doctorate in chemistry at Rutgers and Penn State Universities, respectively. He served as a US Air Force officer, worked as a research scientist for two California firms, and spent a year in Germany and Israel as a visiting scientist. Upon returning to the United States, he and partner Richard Baker founded Bend Research, Inc. to develop new technologies for industry. Lonsdale was also founding editor of the international *Journal of Membrane Science* and published nearly 100 scientific papers and patents. He was named Oregon's first Small Business Entrepreneur of the Year by *Oregon Business Magazine* and served on the board of the Oregon Business Council.

Lonsdale left Bend Research in 1987 to challenge incumbent senator Mark Hatfield in the 1990 general election. Hatfield beat him 54-46 percent. He ran twice again for the Senate as a Democrat, losing both the 1992 and 1996 primaries. Lonsdale's book *Running: Politics, Power, and the Press* was published in 2002. He moved to Southern California to pursue diverse interests, including political campaign finance reform and the science-based origin of life. He died in Indio, California, in November 2014 at age 82.

Bend Research, Lonsdale's legacy, which had a long-term collaboration with Pfizer even as it worked with other companies, remains a pioneer in pharmaceutical science and a cornerstone of high-tech industry in Central Oregon. In 2013, Bend Research was acquired by Capsugel and is part of that company's Dosage Form Solutions division.

"Harry was a great man," said Rod Ray, Lonsdale's successor at Bend Research. "Harry was the founder of Bend Research, and through that accomplishment, transformed the lives of all of us, as well as many other folks . . . in Bend, and all over the United States." (Courtesy of Deschutes County Historical Society.)

J.L. "Jan" Ward, Developer
A lifelong Bend resident, Jan Ward attended
Oregon State University before he built the
residential communities of Timber Ridge,
Nottingham Square, Tillicum Village, and
Mountain High in southeastern Bend. The
Boys and Girls Club in downtown Bend
and many other local civic causes greatly
benefitted from his generosity. He died in
January 2015. (Courtesy of Jody Ward.)

Bob Thomas, Automobile Dealer
A lifelong Bend resident, Bob Thomas earned
a bachelor's degree in history at Stanford
University and served as a US Marine Corps
officer before returning to Bend and a
37-year career at Bob Thomas Chevrolet
Cadillac Honda, the family retail automobile
business. In retirement, he pursued a wide
range of interests, including outdoor athletic
activities, Spanish language and culture,
cooking, and community affairs. (Courtesy of
Deschutes County Historical Society.)

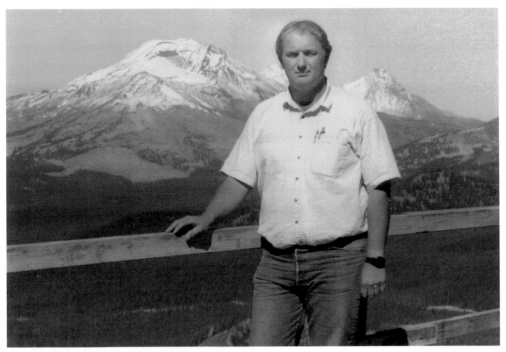

Kirby Nagelhaut, Contractor
After graduating from Bend High School in 1974, Minnesota-born Kirby Nagelhaut worked as a carpenter and project supervisor. He started his own construction company in 1986 and completed more than 1,000 projects—including the Pine Marten Lodge at Mount Bachelor, the Deschutes Public Library in downtown Bend, and the Redmond Airport terminal—before he died at age 55 in June 2012. (Courtesy of Deschutes County Historical Society.)

Dennis Oliphant, River Outfitter
In 1978, Dennis Oliphant founded Sun Country Tours with eight employees and four rafts as "professionals in whitewater rafting and adventure" intent on becoming "the finest river outfitting company possible." As a result of its focus on family adventuring on the Deschutes River, his Bend-based company evolved into one of the larger and more respected river outfitters in the Pacific Northwest. (Courtesy of Deschutes County Historical Society.)

Pamela Hulse Andrews, Editor and Publisher

Pamela Hulse Andrews arrived in Bend in the mid-1990s and soon became the founder and publisher of Cascade Publications, Inc., which publishes both the print and online versions of *Cascade Business News* and *Cascade Arts & Entertainment.* Through these periodicals, she has championed the growth of the arts in Central Oregon and played a leadership role in developing the region's economic vitality. (Courtesy of Cascade Publications, Inc.)

John Kenneth Asher, Book Manufacturer and Distributor

John Kenneth "Ken" Asher (right) founded Maverick Publications, Bend's and Central Oregon's largest book manufacturing company, now owned and operated by his son Gary Asher (left). Born in the family farmhouse on Grand Island, Oregon, in 1931, Asher served as a radioman in the US Navy during the Korean War and worked 15 years for Pacific Northwest Bell before he founded Maverick Publications. (Courtesy of Maverick Publications.)

Gary Fish, *Craft Brewer*

In 1987, as Bend emerged from economic recession, Gary Fish found it "a nice town to open a little pub, make some good beer and good food, and have a good life." He opened the Deschutes Brewery & Public House, Bend's first brewery, at 4:00 p.m. on Monday, June 27, 1988, and brought America's craft brewing movement to Central Oregon. More craft brewers followed to create the incredible brewing community for which Bend has become famous.

Only two years before, Oregon's legislature had passed its "Brewpub Bill," which legalized on-site sales of beer directly to customers. This paved the way for the restaurant-microbrewery industry that soon boomed in Bend. By 2014, Fish's Deschutes Brewery, the leader of 18 thriving Bend breweries, had grown into the seventh largest craft brewery in the United States and the country's 11th largest brewery. Deschutes Brewery shipped beer to 27 states and other markets around the world and, in October 2014, added the Washington, DC, and Northern Virginia markets.

This success reflected Fish's philosophy of letting brewmasters experiment. The result has been a quarter of a century of explosive growth, reflected in a popular range of diverse and award-winning beers led by Black Butte Porter and Mirror Pond Pale Ale. Mirror Pond has consistently won awards in the pale ale category, and Black Butte is the best-selling craft porter in the nation. The brewery's spring seasonal, Red Chair Northwest Pale Ale, was named the World's Best Beer in 2012.

In 2012, the Deschutes Brewery facility was expanded by 6,750 square feet and its production capacity by an additional 105,000 barrels per year. All of this growth has been accomplished in an environmentally friendly process, which conserves water, captures carbon dioxide from the fermentation process, and decreases waste discharge to the city's sewer system.

In June 2013, Fish was recognized by Ernst & Young as Pacific Northwest Entrepreneur of the Year, and the Deschutes Brewery was named among *Outside Magazine*'s 100 Best Places to Work in 2013 and 2014. By founding and building Deschutes Brewery, Fish has contributed to Bend's success as one of the nation's great communities in which to live and work. (Courtesy of Deschutes Brewery.)

George Palmer Putnam, Newspaper Reporter

George Palmer Putnam, scion of New York City publishing company G.P. Putnam's Sons, went west in pursuit of fortune and, in May 1909, found himself in Bend. He went to work as a stringer for the Portland *Oregonian* in July 1909 and soon was roughing it in the wilds of Central Oregon, covering Bend's agent of change—the coming railroad—and the famous Hill-Harriman railroad construction war. He was 21 years old. (Courtesy of Deschutes County Historical Society.)

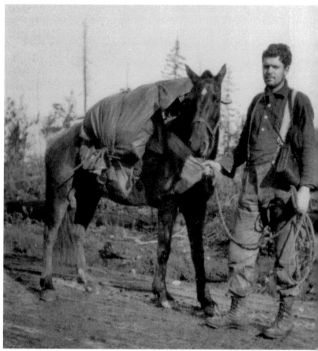

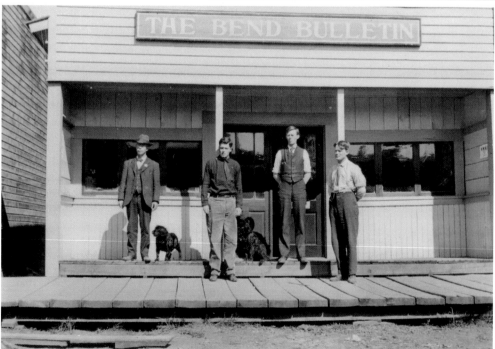

George Palmer Putnam, Newspaper Editor and Publisher

At 22, Putnam was co-owner with James M. Lawrence (left) of the *Bend Bulletin*, which he published with the assistance of Charles D. Rowe, managing editor (third from left), and Ralph Spencer, printer (right). He became mayor of Bend at age 24. (Courtesy of Deschutes County Historical Society.)

Dorothy Binney Putnam, Heiress and Newspaper Publisher's Wife
In September 1911, as the railroad approached Bend, Putnam went east to marry Dorothy Binney, heiress to the Crayola fortune. Binney, shown "paddling her own canoe" on the Deschutes River in 1912, had rowed on the Wellesley College crew and was an early and active feminist. Their son David was born the next year. (Courtesy of Deschutes County Historical Society.)

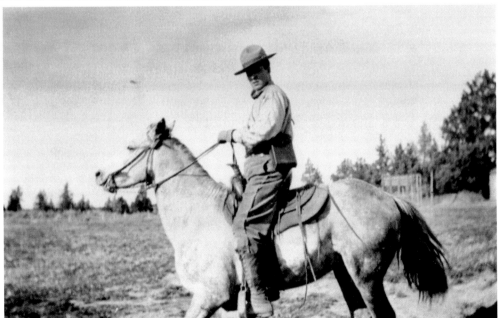

George Palmer Putnam, Moving On and Up
By the time he went to Salem in 1914 to serve as Gov. James Withycombe's personal secretary, Putnam had influenced Central Oregon's future more than any other citizen. After World War I took him to Washington, DC, Putnam did not return to Bend and sold his interest in the *Bend Bulletin* to Robert W. Sawyer. In New York, Putnam's career as publisher, publicist, and motion picture executive led to divorce from Dorothy in 1929 and marriage to one of America's most famous women, Amelia Earhart, in 1931. Putnam died in California on January 2, 1950. (Courtesy of Deschutes County Historical Society.)

Robert W. Sawyer, Editor and Publisher

Robert W. Sawyer succeeded George Palmer Putnam as editor and publisher of the *Bend Bulletin* and became a leading Oregon citizen. "Republican in politics, conservative in outlook, and scrupulous in business affairs," as historian William L. Lang characterized him, Sawyer "was a community force when central Oregon's natural resource economy was in its heyday."

Sawyer was born in Bangor, Maine, in May 1880. He attended Phillips Exeter Academy, Dartmouth College, and graduated cum laude from Harvard Law School. After practicing law in Boston for a few years, he moved west to Bend in 1912. He went to work at a mill and wrote short articles for the *Bend Bulletin*, which he anonymously slipped under the door of Putnam's office. Putnam liked the articles, published them, caught him in the act of delivering one, and offered him a job. Sawyer became editor when Putnam moved to Salem in 1914. He purchased Putnam's interest in the paper in 1919 and continued as editor and publisher until 1953. Sawyer developed many fine, young journalists.

From this influential desk, Sawyer was instrumental in carving Deschutes County out of Crook County, establishing St. Charles Hospital, and promoting agricultural and economic development as well as natural resource conservation. He served as Deschutes County judge from 1920 to 1927. As a member of the Oregon Highway Commission from 1927 to 1930, he promoted uncut forest corridors along highways and expansion of Oregon's state parks. He served on commissions to reconstruct the state capitol building after it burned in 1935 and to design Salem's new campus. A member of diverse organizations, he was a director of the American Forestry Association and president of the National Rifle Association. He had a keen interest in state and local history. Sawyer supported Thomas E. Dewey for president of the United States in 1948 and was thought to be Dewey's choice for Secretary of the Interior.

Sawyer sold the *Bend Bulletin* to Robert W. Chandler in 1953. He was inducted into the Oregon Newspaper Hall of Fame. Sawyer died in Bend on October 13, 1959, at age 78. (Courtesy of Deschutes County Historical Society.)

Robert W. Chandler, Editor and Publisher

Robert W. Chandler purchased the *Bend Bulletin* from Robert W. Sawyer in 1953 and ran the newspaper for the next 43 years, changing its name to the *Bulletin* in 1963. He brought new technology to the paper as it grew with the community.

Chandler was born in Marysville, California, on May 12, 1921, and grew up on the family's farm near Yuba City, California. He earned a journalism degree at Stanford University, served as a special agent in the US Army Counterintelligence Corps during World War II, and began a postwar journalism career at a small weekly newspaper in Northern California. After working on the *San Francisco Chronicle* and the *Denver Post* and as a reporter and bureau manager for United Press International in several western cities, he edited and published Bend's daily newspaper and founded Western Communications, Inc., as owner of his growing chain of local newspapers in Oregon and California.

A civic leader, Chandler ran for the US House of Representatives in 1962 but was defeated by incumbent congressman Al Ullman. He helped establish and was a major donor to The High Desert Museum, south of Bend, and generously supported education programs at the University of Oregon and Central Oregon Community College and other educational endeavors. He served as national president of the Society of Professional Journalists and on the board of directors for the American Society of Newspaper Editors and the American Press Institute. He was a Pulitzer Prize juror, member of Harvard University's Nieman Fellows selection committee, and senior fellow of Columbia University's Freedom Forum Media Studies Center. He was named Oregon Philanthropist of the Year in 1990.

Chandler married Nancy R. Chandler, and the couple had six children. After her death, he took a second wife, Marjorie. Chandler died on July 12, 1996, at age 75. He was inducted into the Oregon Newspaper Hall of Fame that same year. (Courtesy of the *Bulletin*.)

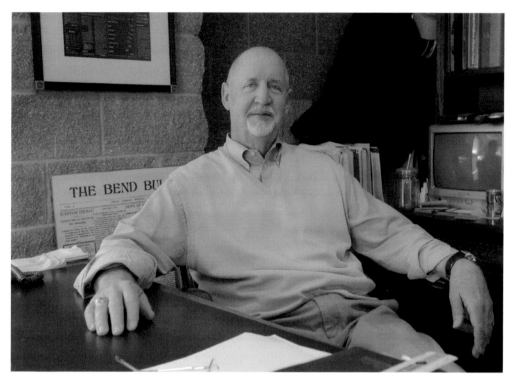

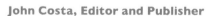

Gordon Black, Editor and Publisher

Born in 1947 in St. Louis, Missouri, and educated at the University of Missouri, Gordon Black is a career newspaperman who worked for newspapers in Delaware, Des Moines, and New York before becoming publisher of the *Idaho Statesman* in Boise, Idaho. He came to Bend in 1994 as publisher of the *Bulletin* and president of its parent company, Western Communications, which publishes seven newspapers in Oregon and California. He retired on January 31, 2015. (Courtesy of the *Bulletin*.)

John Costa, Editor and Publisher

A native of New York who graduated from Villanova University and served as a US Army officer in Vietnam, John Costa has been a newspaperman since 1969. He was executive editor of the *Idaho Statesman* in Boise, Idaho, before he arrived in Bend in 1997 to be editor of the *Bulletin*. With Gordon Black's retirement in 2015, Costa became publisher of the *Bulletin* and president of Western Communications. (Courtesy of the *Bulletin*.)

CHAPTER FIVE

Doctors and Lawyers

Members of both of the medical and legal professions were drawn to Bend during its earliest years—and still are—by both the need for their services and the attractiveness of and prospects for good lives and successful practices in this singular community.

Charles Spencer Edwards, MD, was Bend's first physician. But it was a successor, legendary local Urling C. Coe, MD, who became the newly incorporated city's true "frontier doctor" as well as a leading citizen. In a way, Dr. Coe served as a role model for Bend physicians. Some of his early colleagues and successors arrived in Bend from other places, but at least one was homegrown. Of pioneer rancher William Plutarch Vandevert's three sons who became medical doctors, legendary local John Clinton Vandevert, MD, returned to Bend from medical school to make his mark as a physician and citizen. He was one of several physicians whose decades-long practices proved part and parcel of Bend's evolution from a small town of country doctors to a major regional medical center in which hundreds of physicians and allied health care professionals provide a full range of world-class medical services. A significant number of these physicians participate in community affairs in such diverse ways as representing its citizens in the state legislature to leading the local rugby club.

Attorneys have made similar contributions as legal professionals and community leaders who enabled Bend to prosper and grow. Among the city's leading law firms, Karnopp Petersen LLP has roots extending to 1935, when Duncan McKay, son of legendary local Clyde McKay, opened a practice on Oregon Street. McKay partnered with legendary local Owen M. Panner in 1950, and their firm grew in ensuing decades. Panner eventually left to become a US District Judge for Oregon. The firm continues to serve many of the same clients it has since inception— including the Confederated Tribes of the Warm Springs Reservation of Oregon—with a focus on individuals and businesses. Attorneys in other Bend law firms have been elected to the state legislature and appointed to judgeships.

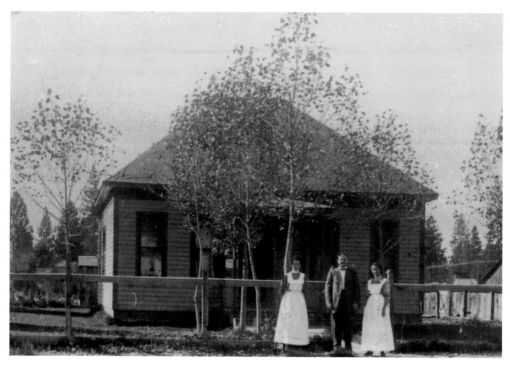

Urling C. Coe, Frontier Doctor

Dr. Urling C. Coe stood with Fern Hall and a nurse outside Mrs. Hall's Hospital on Oregon Street in Bend. Bend's first hospital opened in 1909 and was in use until 1914; Coe practiced medicine in Bend from 1905 to 1918.

Born in 1881 as a Missouri native and the son of a doctor, Coe graduated from the University of Missouri and studied medicine at the Eclectic Medical College in Cincinnati, Ohio, before arriving in Bend as the *Frontier Doctor* in his 1940 memoir.

"I came to Bend on January 10, 1905, a young medic 23 years old, eager to get going," he wrote. And so was Bend. Only a year earlier, a major irrigation project brought hundreds of workers to the area. There were two other doctors in town at the time, but neither was licensed to practice in Oregon, and both left town when Coe opened his practice. A third retired doctor operated a drugstore. As Carol Blackwell wrote in the winter of 2002–2003 issue of *Cascades East*, this burgeoning population was remote from medical services. "The nearest railroad was 100 miles away. The nearest doctor to the north was 90 miles away, to the west 120 miles away, and to the south 94 miles. Prineville, a mere 35 miles away had four doctors. The county did not have any graduate nurses and the nearest hospital was 160 miles away. Dr. Coe was the only doctor practicing in the Bend area then, covering a tremendous territory reaching many miles and hours, in all directions."

Travel was by buggy or on horseback. Coe preferred the buggy, in which he could carry all his medical supplies on remote calls. These, as he recalled in *Frontier Doctor*, included "a medicine case which included 54 different drugs," an obstetrical bag, a canvas bag "filled with . . . everything needed in a fracture case, . . . an amputating outfit and all the instruments needed for an operation of any kind," and "an emergency bag with anesthetics, antiseptics, soap, sterile towels and dressings."

Dr. Coe was active in Bend's development. He was the city's second mayor, a banker and bank president, and a real estate investor. He left Bend in 1918 for Portland, where he practiced medicine for more than a quarter of a century. He died in May 1956 at his home in Oswego at age 75. (Courtesy of Deschutes County Historical Society.)

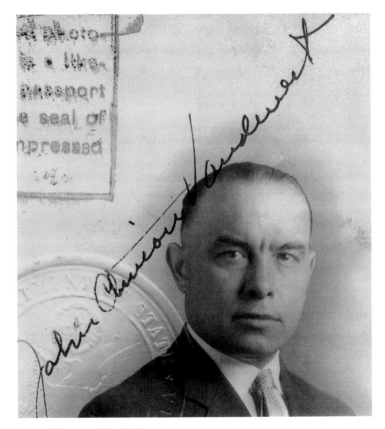

John Clinton Vandevert, Physician

John Clinton Vandevert, MD, known as "Dr. Clint" and shown here in his passport photograph, was a beloved and respected physician in Bend for 50 years. Born in 1887 in Holbrook, Arizona, to William P. and Sadie Vandevert, he moved with his family to the Vandevert Ranch on the Deschutes River south of Bend in 1892 and grew up on the ranch. He and brothers George and Arthur, who began their educations in a one-room log schoolhouse north of the ranch, became medical doctors.

A graduate of Willamette College in Salem who studied medicine at the University of Oregon Medical School in Portland, Vandevert opened his Bend practice on July 15, 1915, to become Bend's third physician. Dr. Urling C. Coe and Dr. B. Ferrell were the other two. In 1916, he moved his practice to the new O'Kane Building and became one of its first tenants. Also in 1916, he helped found the Bend Surgical Hospital and married Harriet Louise Dolson in Maywood, Illinois, his wife until she died in 1960.

That hospital reflected Vandevert's concern about the dangers of childbirth when deliveries were often performed under makeshift and unsanitary conditions. It closed during the 1920s, when the first St. Charles Hospital was established in downtown Bend. Throughout his medical career, Vandevert's manner was that of the unhurried and dignified family doctor. His patients had faith in him, and Vandevert had faith that he had, in all probability, brought more Bend babies into the world than any other Bend doctor.

Vandevert was an avid hunter and outdoorsman. He was appointed to the Oregon State Game Commission and twice served as state president of the Oregon State Trapshooters Association. He was a top shooter in the skeets class and other gun trials. He frequently won Bend's annual "turkey shoot" and took the prize to the Vandevert Ranch for the family Christmas dinner. He owned land near the ranch on which he built a cabin that he and his wife stayed in when they visited the ranch. He also owned land on Awbrey Butte, which he donated to help build Central Oregon Community College. He died in 1965 soon after retiring from his practice. (Courtesy of Deschutes County Historical Society.)

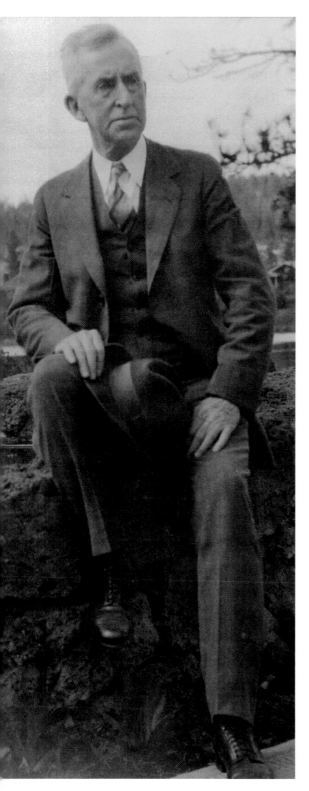

Charles A. Fowler, Physician and Health Inspector

Charles A. Fowler, MD, who lived in Bend from 1919 until his death in 1941, served as the city's health inspector and maintained a private practice in the 1920s and 1930s.

Born in Illinois in 1858, Dr. Fowler attended public schools in Galena, graduated from Chicago Medical College in 1884, and went into practice with his father, Dr. Benjamin Franklin Fowler, in Galena. But, because his father's patients refused to take the young doctor seriously and insisted on seeing the older Dr. Fowler whom they knew and trusted, the younger doctor moved to Sundance, Wyoming, where he practiced medicine, was partner in a drugstore, and broke a few horses on the side. He really did not want to be a doctor but did so to please his father.

In 1888, at age 29, Dr. Fowler married a young woman from Buffalo, New York, and moved his practice to Iowa, where their three children were born. They moved on to Illinois, then to Oregon, where he practiced in Dufur and Portland before relocating to Bend in 1919. They lived on West Seventh Street in Bend before moving into a house they built at 636 Riverside Drive, where three generations of the Fowler family lived comfortably.

As health inspector, Dr. Fowler served the public good. In 1928, for example, a number of Bend families were quarantined for scarlet fever, diphtheria, and meningitis. There was also a case of typhoid fever that year. At the time, Bend had numerous individual cesspools, which no doubt influenced the spread of contagious diseases.

As a private practitioner, Dr. Fowler's charge for a house call was between $1 and $2.50; to deliver a baby—which he referred to as "attending"—$25 and sometimes $35 if there were complications. Times were hard, and at least a third of these charges went unpaid. Patients often paid in vegetables, meat, poultry, home-canned and baked goods. Still, he and his family considered themselves fortunate. Even during the Great Depression, there was always food on the Fowler family table, thanks largely to his patients. (Courtesy of Deschutes County Historical Society.)

Harry Mackey, MD, Physician
Born in Spokane, Washington, in 1904, Harry Mackey graduated from the University of Oregon Medical School in 1931, took his internship and two-year residency in obstetrics and gynecology at Multnomah County Hospital in Portland, Oregon, and went looking for work. The death of an elderly physician in Bend created a vacancy, and Dr. Mackey had all the patients he could handle for his 50-year career. He died in April 1982. (Courtesy of Deschutes County Historical Society.)

W.G. Manning, Pioneer Dentist
Fresh out of North Pacific Dental College in Portland, Oregon, W.G. Manning visited Bend in 1915 and found himself "bending elbows" with Dr. Urling C. Coe in a Bond Street saloon. Bend's prominent physician convinced him that Bend was the place to practice dentistry, and Dr. Manning did just that, in the same office in the O'Kane Building for 66 years, until he retired in 1981. (Courtesy of Deschutes County Historical Society.)

James Delp, MD, Ophthalmologist
James Delp, MD, was a Bend ophthalmologist from 1971 to 1998. Born in 1933 on a farm near Lititz, Pennsylvania, he earned a bachelor of science degree at Goshen College in Indiana and a medical degree at Jefferson Medical College in Philadelphia in 1959. After serving as a doctor on the Hoopa Indian Reservation in California, Delp specialized in ophthalmology in Portland, Oregon, from 1962 to 1965. There, he met and married an elementary school teacher, Dory. (Photograph by Les Joslin.)

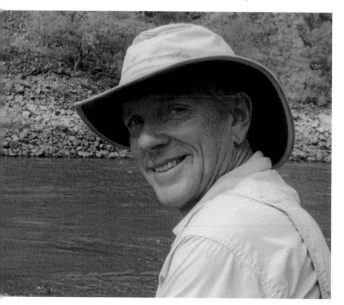

Stuart R. Garrett, MD, Physician as Botanist
A 1975 graduate of the University of Kentucky College of Medicine, Dr. Stu Garrett specialized in family medicine at Oregon Health & Science University in Portland before moving to Bend, opening a practice, and pursuing an avid interest in botany. He cofounded the Central Oregon Chapter of the Oregon Native Plant Society in 1979, guided designation of the Newberry National Volcanic Monument in 1990, and became a recognized champion of the region's natural environment. (Photograph by Hilary Garrett; Courtesy of Dr. Stu Garrett.)

M. Jamie McAllister, DO, Family Care Physician
Jamie McAllister was born in Seattle, Washington, attended Colorado College, and graduated from Florida State University. A 1985 graduate of Kirksville College of Osteopathic Medicine in Kirksville, Missouri, "Dr. Jamie" has practiced in Bend since 1991, except for five years on Annette Island in southeastern Alaska as a Metlakatla Indian community physician. (Photograph by Les Joslin.)

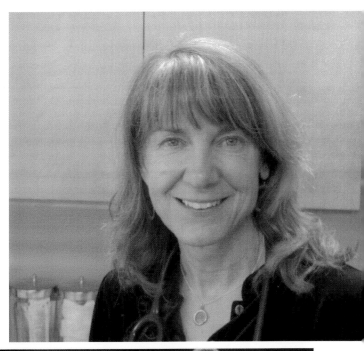

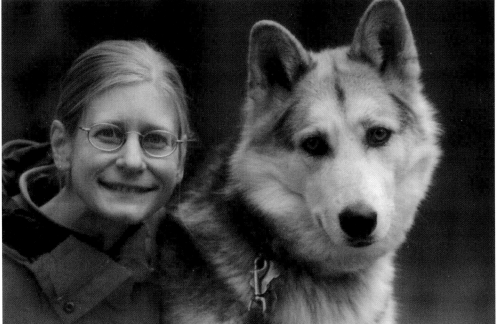

Molly Johnson, Physical Therapist
A physical therapist from Iowa, Molly Johnson represents hundreds of helping professionals who have chosen Bend as a place to live and work. A graduate of College of St. Benedict in St. Joseph, Minnesota, she earned a master's degree in physical therapy at the University of South Dakota before moving to Bend in 2007. An avid backpacker, Johnson is an Oregon wilderness fixture—as was, for many years, her wolf-dog Chinook. (Photograph by Les Joslin.)

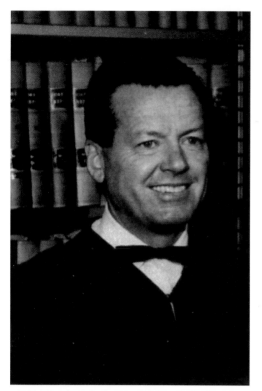

Robert H. Foley and Terrance H. Foley, a Judge and his Father

Born in Bend in 1911, Robert H. "Bob" Foley graduated from Bend High School in 1929 and the University of Oregon Law School in 1935. Starting his career as a lawyer, he became Deschutes County district attorney in 1940. Although away during World War II, serving as a US Army Signal Corps officer in the South Pacific, Deschutes County voters reelected him as district attorney. He went on to serve as circuit court judge for Deschutes, Crook, and Jefferson Counties before retiring as an Oregon Court of Appeals judge in 1976.

Judge Foley was a son of civic leader Terrance H. Foley, a Canadian immigrant who arrived in Bend by covered wagon in 1910 and, beginning in 1912, served as vice president and general manager of Bend Water, Light and Power until killed in an automobile accident in 1925. (Both photographs courtesy of Deschutes County Historical Society.)

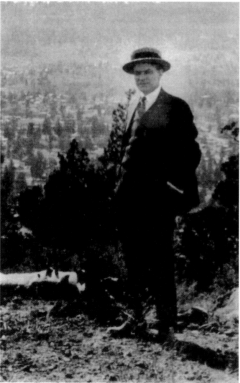

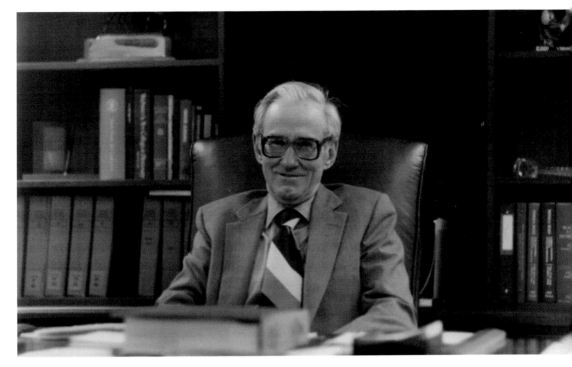

Owen M. Panner, Federal Judge

Owen M. Panner spent 30 years in Bend as a trial lawyer before Pres. Jimmy Carter appointed him to the federal bench in Portland. He began serving on the US District Court for the District of Oregon in 1980 and was chief judge of the court from 1984 to 1990.

Panner was born in Chicago, Illinois, in 1924, but grew up in Whizbang, Oklahoma, where his geologist father worked in the oil fields during the Great Depression. After high school, he attended the University of Oklahoma for two years before he served in the US Army from 1943 to 1946 in transportation and logistics coordination. After his discharge, he entered law school at the University of Oklahoma, where he earned a bachelor of laws degree in 1949.

Hearing that Central Oregon was a scenic place to live, Panner and his young family moved to Bend in 1949, and he began practicing law in 1950. He served a variety of clients and was general counsel for the Confederated Tribes of Warm Springs. He turned down the position of commissioner of the Bureau of Indian Affairs, offered by Pres. John F. Kennedy, and remained in Bend. He was vice president of the Oregon State Bar and a member of its board of governors from 1961 to 1963, as well as president of its Central Oregon chapter. He became a fellow of the American College of Trial Lawyers and was named Oregon Trial Attorney of the year in 1973 by the American Board of Trial Advocates.

Three years after his elevation to the federal bench, Judge Panner told the *Bulletin* in 1983 that he experienced very little culture shock in making the move from small-town Bend lawyer to big-town Portland judge. "I love Bend," he said, explaining how he and his family had stayed there when other opportunities to leave had arisen. "But I've always had the view that you should be open to change."

As of 2014, Judge Panner and his family lived in Medford, Oregon, where he presided at the James A. Redden US Courthouse. (Courtesy of Deschutes County Historical Society.)

Neil R. Bryant, Attorney and State Senator
Neil R. Bryant, born in Spokane, Washington, in 1948, earned a bachelor of arts degree at Pacific Lutheran University in 1970 and a Juris Doctor degree at Willamette University in 1973. Bryant is a Bend attorney who served in the Oregon State Senate from 1993 to 2000. A shareholder in Bryant, Lovlien & Jarvis, PC, he practices business, corporate, water, labor, and real estate law and has served on many state and local boards and commissions. (Courtesy of Deschutes County Historical Society.)

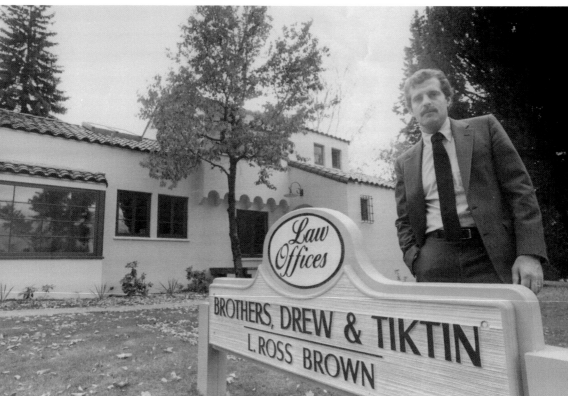

Stephen H. Tiktin, Attorney and Judge
Stephen H. Tiktin, who earned bachelor of science and Juris Doctor degrees at the University of Oregon, was a prominent Bend attorney and judge. Admitted to the Oregon State Bar in 1973, Tiktin was an assistant district attorney in Lane County and a partner in the Bend law firm of Brothers, Drew & Tiktin before he served as a Deschutes County Circuit Court judge from 1989 until he retired at the end of December 2011. (Courtesy of Deschutes County Historical Society.)

CHAPTER SIX

Preachers and Teachers

From the beginning of settlement, preachers (pastors, priests, and rabbis) and teachers (public school teachers, college professors, school administrators, and other storytellers) have served the spiritual and intellectual lives of Bend. The same log cabin on the Deschutes River sheltered the first meetings of school classes and church congregations.

The residents of Farewell Bend established a school as early as 1881. A school district was organized in 1882, and Mae Barnes became Bend's first teacher in 1883. A new one-room schoolhouse, built near the north end of Wall and Bond Streets, was occupied in 1903. Within a year, growth to almost 50 students required the hiring of two more teachers and renting of space in other downtown buildings. Ruth Reid, who arrived in Bend in 1904 from New Brunswick, Canada, taught in and served as principal of this school. She also taught high school classes and laid the groundwork for a four-year high school.

The new Central School was built in 1905 and occupied in 1906 by over 200 students. Bend's first high school class of four graduated in 1909. The town and its school system continued to grow. In 1914, the modern, three-story Reid School—named for pioneer teacher Ruth Reid—opened. Other grade schools (public, parochial, and private) and high schools followed, and a community college began in 1949. Today, Bend boasts 15 elementary schools, five middle schools, four high schools, Central Oregon Community College, and an evolving Oregon State University-Cascades campus, as well as several private and church-sponsored schools.

The first sermon preached in Bend seems to have been delivered by a Methodist minister named McDonald in that little log schoolhouse in 1900. From an apparently modest ecumenical beginning, Bend's denominations soon differentiated, organized as congregations, and eventually built the structures in which they worshiped. Presbyterians organized their congregation in 1903. Baptists seem to have constructed Bend's first church building in 1904, and the Methodists in 1906. In their wakes followed Lutherans, Episcopalians, and other Protestants. In 1904, Rev. Michael J. Hickey said the first Catholic Mass in a hall over the Bend Mercantile Store for seven Catholic families and five unmarried men, and in 1909, Bend's 1903 one-room school building began service as the city's first Catholic church. All these and others built new facilities over the ensuing years. Today, Bend lists almost 60 churches.

Education and inspiration occur outside the classroom and the sanctuary. The world-class High Desert Museum, south of Bend, interprets the natural and cultural history of the Intermountain West. The Deschutes Historical Museum in Bend's old Reid School building tells the stories of Deschutes County, and individual legendary locals teach and inspire. Among many was Myrlie Evers-Williams, widow of civil rights leader Medgar Evans, killed in 1963, who moved to Bend in 1989. Chairwoman of the National Association for the Advancement of Colored People (NAACP) from 1995 to 1998, she lived in and worked from Bend until 2013.

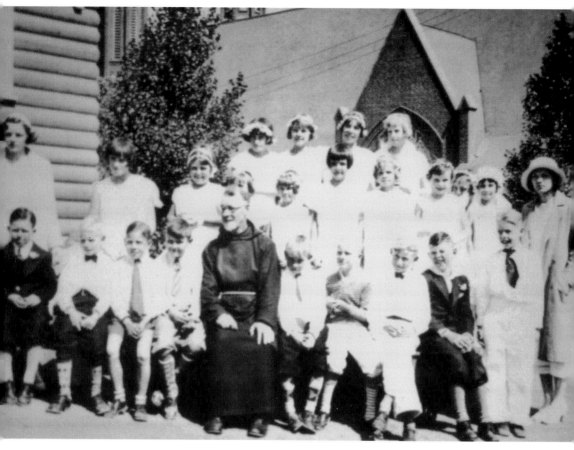

Fr. Luke Sheehan, Pioneer Parish Priest

Fr. Luke Sheehan arrived in Bend in 1910 from his native Cork, Ireland, and within 10 years built the town's St. Francis of Assisi parish church. Born in March, 1873, he entered the Franciscan Capuchin Order in 1889 and was ordained in July 1896. He volunteered for mission work in Aden, then a British protectorate on the southern Arabian Peninsula, where he ministered to British army and naval stations and later served Catholic soldiers in the British Army in India until the end of 1908.

When he arrived in Bend, he began ministering to his parish in the town's first Catholic church, a converted schoolhouse near the corner where Wall and Bond Streets merge. By 1914, his parish included Warm Springs, Redmond, Madras, Prineville, La Pine, Tumalo, Sisters, and even the Fort Rock Basin community of Fleetwood. He had a parochial house in Bend, a church in Redmond, and a building for a church in Madras. The next year, he built and dedicated a church in Prineville. At the same time he brought the Sisters of St. Joseph from Indiana to Bend to staff the first and second St. Charles Hospital, having secured the old water tower hill site for the new brick structure completed in 1922. When the Brooks-Scanlon and Shevlin-Hixon sawmills opened in 1916, Bend's population outgrew the school building-church. A new church was needed, and the cornerstone for St. Francis Parish Church was laid on January 25, 1920.

Father Luke, as he was affectionately known, died on February 11, 1937. His was one of the larger funerals held in Bend and filled to overflowing the sturdy brick church he had built. Burial was at Pilot Butte Cemetery. Only the year before, he had established a parochial school in Bend, contracted for its construction, and arranged for Sisters of the Holy Name to teach the 140 children who enrolled in St. Francis School in September 1936. (Courtesy of Deschutes County Historical Society.)

Rev. William Clyde Stewart, Methodist Pastor
This stained glass window at the First United Methodist Church in Bend is dedicated to Rev. William Clyde Stewart. As pastor, his most selfless act was also one of his last. When the influenza pandemic struck in 1918, Stewart served hundreds of ill Bend residents, regardless of religious affiliation. He sometimes conducted three funerals in one day. Exposed to the deadly virus, Stewart died from it at age 36. (Courtesy of the *Bulletin*.)

Rev. Evangelist Kelly, Parish Priest
Rev. Evangelist Kelly guided Bend's St. Francis of Assisi Catholic parish twice—from 1976 to 1985 and 1991 to 1997—during two of the city's biggest growth spurts. He left Bend in August 1977 at the age of 76 for a new post as an assistant pastor in Burlingame, California, the western headquarters of the Capuchin Franciscan Order to which he belonged. He loved Bend, and his parishioners loved him. (Courtesy of Diocese of Baker.)

Sr. Catherine Hellman, Medical Administrator

Born in Terre Haute, Indiana, on September 25, 1921, Kathryn Lucille Marie—one of 15 children born to John Henry and Philomina Hellman—grew up working on the family farm. As Sr. Catherine Hellman, she became Bend's leading health care administrator.

In 1941, when five of her brothers went into the US Army, the young graduate of St. Joseph Academy in Tipton, Indiana, joined the Sisters of St. Joseph as a postulant. She began a long career in health care at Mercy Hospital in Elwood, Indiana, after graduating in 1946 from Good Samaritan School of Nursing in Kokomo, Indiana, and professing perpetual vows in 1947. She moved to Bend that year to work at St. Charles Hospital, where she served as nursing supervisor from 1948 to 1951. She returned to Indiana to serve in positions of increasing responsibility at St. Joseph's Hospital in Kokomo. She earned a bachelor of science degree in business administration in 1966 at Mount St. Joseph College in Cincinnati, Ohio, and a master's degree in health care administration in 1968 at St. Louis University in St. Louis, Missouri. A master's degree in applied spirituality from the University of San Francisco rounded out her formal education in 1991.

Sister Catherine returned to Bend in 1969 and served as president and chief executive officer of St. Charles Medical Center until 1989 and then as president until 1995. Along with her colleagues, she envisioned this regional medical center as a place of patient and family-centered compassionate care provided by dedicated, team-oriented physicians and associates. Bend honored Sister Catherine by naming her Woman of the Year in 1975 in recognition of her dedication and commitment to the community. St. Charles Medical Center received the coveted Norman Cousins Award for Excellence as it continued the tradition of the Sisters of St. Joseph by meeting the needs of all.

In 2000, Sister Catherine returned to Tipton, Indiana, where she died peacefully on September 27, 2009, at the age of 88. (Courtesy of Deschutes County Historical Society.)

Rev. Joseph Nicholas Reinig, Catholic Priest

Rev. Joseph Nicholas Reinig spearheaded construction of Bend's new St. Francis Catholic Church, completed in 2009. Born in 1932 in Berkshire Heights, Pennsylvania, he grew up in Reading, Pennsylvania. He married Helen B. Macey in 1953, and they had nine children while he worked in the space program as an engineer. After his wife died in 1993, Reinig studied for the priesthood and was ordained in 1998. He died in October 2014. (Courtesy of Diocese of Baker.)

Rev. Donald McRae Beake, Lutheran Minister

Born in 1931 in Youngstown, Ohio, where he was ordained into the Lutheran ministry in 1958, Rev. Donald McRae Beake married Jean Ann Sauers of Portland, Oregon, that same year. He served congregations in Lind, Washington, and Sweet Home, Oregon, before arriving at the First Lutheran Church of Bend in 1968 from which he retired in 1994. Active in the community, he died in 2010. (Courtesy of Deschutes County Historical Society.)

Ruth Reid, Pioneer Teacher

Ruth Reid (right), with Pearl Hightower (left), was born in New Brunswick, Canada, and came to Bend in 1904 to teach in Bend's small second schoolhouse. She became the city's first school principal. After the regular school day, she taught high school classes and helped found Bend High School, which graduated its first class of four students in 1909.

Reid's teaching career ended in 1910 when she married James Harrison Overturf, the office manager for Drake Development Company. The Overturfs remained in Bend until 1953, when they moved to Hood River, Oregon, where the pioneer teacher died in 1965. The three-story Reid School, completed in 1914, was named for her. Bend's first modern school building, it now houses the Des Chutes Historical Museum and the Deschutes County Historical Society. (Both photographs courtesy of Deschutes County Historical Society.)

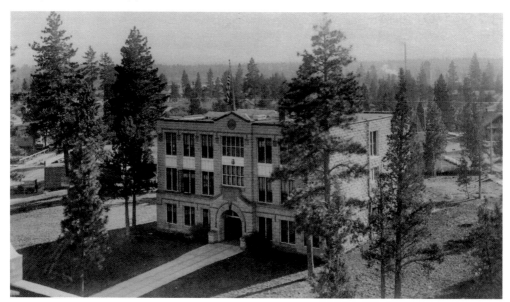

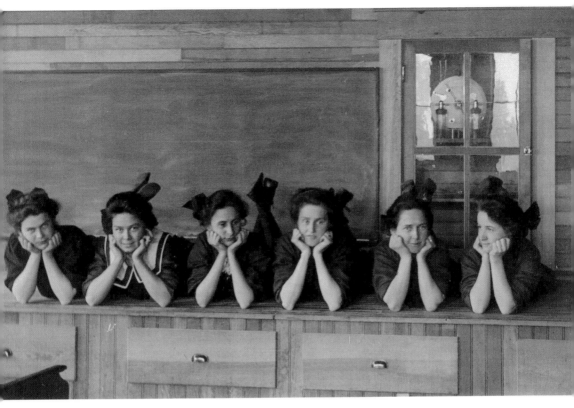

Priscilla Club, Six Young Teachers
From left to right, early teachers are Ann Markel, Maude Vandevert, Marian Wiest, Florence Young, Ruth Reid, and Norma Richardson. They were members of the Priscilla Club, an early social network for proper young ladies of Bend. The club's name possibly referred to Henry Wadsworth Longfellow's poem "The Courtship of Miles Standish" in which Priscilla Mullins suggested John Alden speak for himself when he proposed marriage for another. The short-lived club, which began with 15 members and briefly topped 30, was a prominent and positive influence on the social development of Bend. They taught, they entertained, and they eventually married and raised families in a town they helped tame. (Courtesy of Deschutes County Historical Society.)

Nellie Eliza Tifft, Teacher, Principal, School Board Member

Nellie Eliza Tifft taught fifth and sixth grades at Reid School in 1919 and 1920. Bend boomed, and she became a roving principal for several schools at once. Her teaching career ended when she married Percy Armstrong in 1926. The first woman on Bend's school board from 1939 to 1947, she resumed teaching as a Kenwood School third grade teacher from 1947 until she retired in 1956. (Courtesy of Deschutes County Historical Society.)

Sylvia Addie Veatch, High School Math Teacher

Born in Cottage Grove, Oregon, in November 1900, Sylvia Addie Veatch graduated from the University of Oregon and became a mathematics teacher. After two years in Springfield, she began teaching at Bend High School. A no-nonsense teacher, she believed that student failure reflected her teaching technique and would try another approach. Veatch, who returned to Cottage Grove in 1965 to care for her mother, died in December 1985. (Courtesy of Deschutes County Historical Society.)

Jack Ensworth, National Teacher of the Year 1973

John Arthur "Jack" Ensworth of Bend received the 1973 National Teacher of the Year Award from First Lady Patricia Nixon at a Washington, DC, ceremony. Ensworth taught at Kenwood Elementary School for 26 years. Ensworth Elementary School, opened in September 2004, was named for this representative of the high quality of education in Bend schools. Ensworth died in July 2015. (Courtesy of Deschutes County Historical Society.)

Robert Ewart Jewell, Teacher and Administrator

Robert Ewart Jewell was a Bend educator for whom Jewell Elementary School is named. Born in 1908 in Portland, Oregon, he arrived in Bend in 1930 after graduating from the University of Oregon. He taught mathematics and science at Bend High School, where he was later dean of students, assistant principal, and principal. In 1950, he began 20 years as Bend's superintendent of schools. Jewell died in Bend in 1984 at age 76. (Courtesy of Deschutes County Historical Society.)

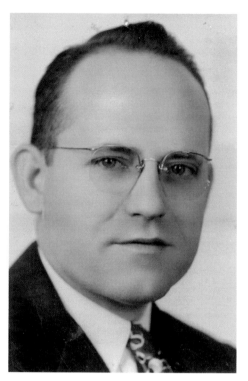

Don P. Pence, Founding Central Oregon Community College President
Don P. Pence was the first president of Central Oregon Community College, serving as director from 1952 to 1957 and president from 1957 to 1967. The fledgling college's enrollment jumped to 114 during his first year and approached 800 on the new Awbrey Butte campus by the time he stepped down. His 1960 Oregon State University doctoral dissertation outlined a statewide community college system, and he became known as the "father of community colleges in Oregon." (Courtesy of Deschutes County Historical Society.)

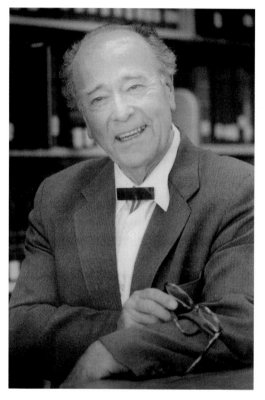

Orde S. Pinckney, Pioneer Central Oregon Community College Professor
Born in August 1917 in Georgetown, Idaho, Orde S. Pinckney earned a University of Utah bachelor's degree in speech and drama in 1940 and master's degree in history in 1942. He received a doctorate in history from the University of California at Berkeley in 1957. Pinckney taught history, political science, and speech at Central Oregon Community College—an institution he helped build that named him its first distinguished professor—from 1955 to 1996. He died in 1997. (Courtesy of Deschutes County Historical Society.)

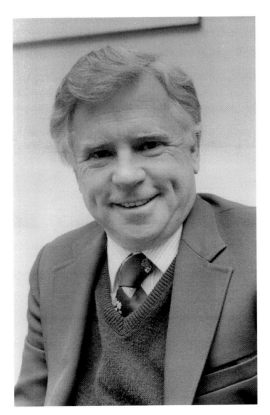

Frederick H. Boyle, Second Central Oregon Community College President
Fred Boyle, a Western State College (Gunnison, Colorado) graduate with a Harvard master's degree and University of Florida doctorate, served as president of Central Oregon Community College from 1967 to 1990, when the college grew from less than 800 students on a seven-building campus to nearly 3,000 students on a 17-building campus. He led development of the college's administrative infrastructure and academic programs and initiated efforts for baccalaureate degree programs. Boyle died on September 26, 2015, at age 87. (Dave Swan photograph courtesy of Central Oregon Community College.)

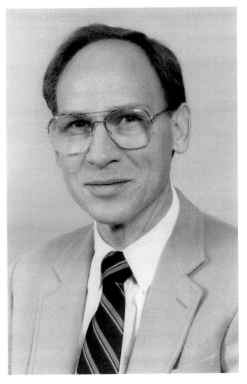

Robert L. Barber, Third Central Oregon Community College President
Robert L. "Bob" Barber served as president of Central Oregon Community College from 1990 to 2004. A 1966 graduate of Cornell University, he served as a US Navy officer from 1966 to 1971 and earned a master's degree in education at the State University of New York at Albany and a doctorate in educational administration at the University of Connecticut. He was president of Southwestern Oregon Community College in Coos Bay from 1985 to 1990. (Courtesy of Deschutes County Historical Society.)

Bruce Nolf, Geology Professor
A brilliant geologist with a Princeton PhD could teach just about anywhere, but Bruce Nolf chose to teach at Central Oregon Community College because he loved the Cascade Ranges and the High Desert. He dispelled their mysteries for students beginning in 1966. Nolf was named the college's second distinguished professor in 1986. (Courtesy of Deschutes County Historical Society.)

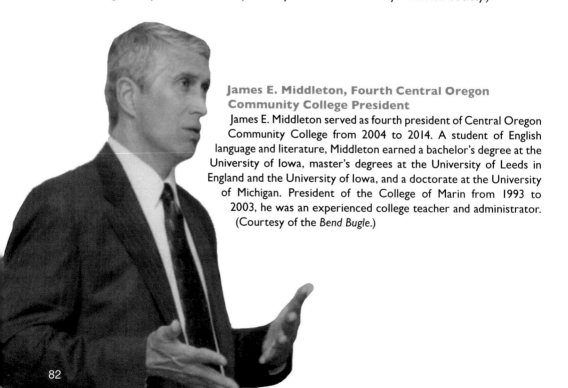

James E. Middleton, Fourth Central Oregon Community College President
James E. Middleton served as fourth president of Central Oregon Community College from 2004 to 2014. A student of English language and literature, Middleton earned a bachelor's degree at the University of Iowa, master's degrees at the University of Leeds in England and the University of Iowa, and a doctorate at the University of Michigan. President of the College of Marin from 1993 to 2003, he was an experienced college teacher and administrator. (Courtesy of the *Bend Bugle*.)

Raymond R. Hatton, Geography Professor

Central Oregon Community College geography professor Raymond R. "Ray" Hatton was born in February 1932 in Litchfield, Staffordshire, England. He rated the title "Geographer of Central Oregon" for all he did to advance knowledge and understanding of the region after he arrived in Bend in 1969.

Hatton was awarded a track scholarship at the University of Idaho in 1956 and graduated with a bachelor of science degree in education in 1960. He then taught high school in California while earning a master's degree in education at Idaho and a master of arts in geography at the University of Oregon. His master's thesis, "The Impact of Tourism in Central Oregon," acquainted him with the region. He completed a doctorate degree in geography at the University of Oregon in 1989.

In 1969, Hatton joined the faculty at Central Oregon Community College, where he taught geography and researched and wrote about Central Oregon geography until he retired in 1993. His focus on Central Oregon geography resulted in several books on the region—*Bend Country Weather and Climate* (1973), *High Desert of Central Oregon* (1977), *Bend in Central Oregon* (1978), *High Country of Central Oregon* (1980), *Pioneer Homesteaders of the Fort Rock Valley* (1982), *Sisters Country Weather and Climate* (1994), and *Oregon's Sisters Country* (1996)—and the unique field course, Geography 198: Central Oregon on Foot, in which he passed on his passion for the region to hundreds of students.

Hatton earned that University of Idaho track scholarship. He became a competitive long distance runner in 1943 and represented England in the International Cross Country Championships at Glasgow, Scotland, in 1952. At the University of Idaho, he ran varsity track and cross country. He won over 40 US Masters championships and held US age group track records. Other interests included cross-country skiing, hiking, climbing, and his family. Hatton died in March 2015. His wife and their two grown children live in Bend. (Courtesy of Central Oregon Community College.)

Donald M. Kerr, Museum Founder

"He had this incredible need and desire to share his love of the out-of-doors, his love of the desert," Cameron Kerr said of her husband, Donald M. "Don" Kerr, who died in February 2015 at age 69. A native of Portland, Oregon, Kerr moved to Bend in the 1970s to pursue his dream of opening a new kind of museum that would interpret the close connections between people and their environment. He realized his dream in what is now The High Desert Museum on US Highway 97, south of Bend.

Kerr's vision grew out of childhood experiences. "I've raised a wolf and two great horned owls," he said. "I've been lucky to have these experiences that aren't possible for most people. I wanted to bring others closer to nature, to experience it, to learn to maintain it." He pursued this vision as an Oregon State University biology student in the late 1960s, exploring Oregon's high desert, where he was enthralled by its birds of prey. After graduation, he worked with birds of prey at the Oregon Zoo and led field trips for university students. As Bend writer Kim Cooper Findling put it in 2011, "Kerr won people over one by one," to his museum vision through "deals over dinner, during which friends and supporters arrived skeptical and left promising money, time or both. Remarkably, this took place in the late 1970s, when Bend was not yet a destination, but a small town struggling to survive on the remnants of a timber economy."

As a result, The Oregon High Desert Museum rose on 135 acres south of Bend donated by the Brooks-Scanlon Corporation. Eventually, to recognize its greater regional role, it was renamed The High Desert Museum. By 1989, the museum was welcoming 100,000 visitors per year, and the facility was significantly expanded.

In 1995, Kerr contracted viral encephalitis while working with a great horned owl. This left him disabled and unable to continue to lead the museum. Although wheelchair-bound and unable to speak, he was mentally alert and a guiding presence at the growing world-class museum of 85,000 square feet of indoor exhibits connected by a quarter-mile trail. A major permanent exhibit, the Donald M. Kerr Birds of Prey Center, was named for him and houses birds like spotted owls and eagles. (Courtesy of the *Bulletin*.)

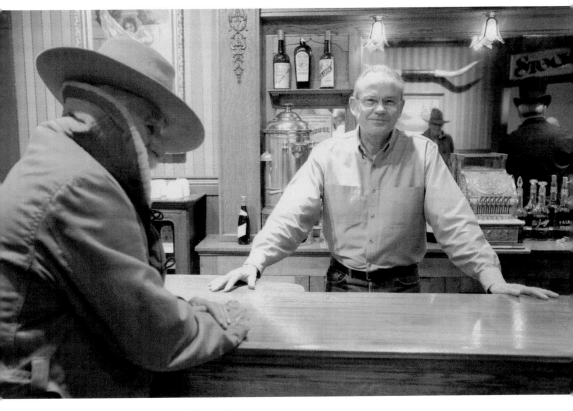

Robert G. Boyd, Western Historian

Robert G. "Bob" Boyd has spent most of his working life interpreting America's past as a public school teacher, consulting historian, and curator of western history at The High Desert Museum, south of Bend. Born in 1948 in Ontario, California, Boyd graduated from Chaffey High School in 1966, earned an associate degree in history at Chaffey College in 1968. He then received bachelor of arts and master of arts degrees in industrial education at California State University at Long Beach in 1971 and 1974 and studied history at Pepperdine University from 1975 to 1976. He served in the California Army National Guard from 1970 to 1976.

After teaching in California, Boyd moved to Bend in 1978 to teach industrial education and history at Cascade Middle School. In the mid-1990s, he moved to High Desert Middle School. As he began teaching, Boyd discovered that artifacts motivated students. He put together classroom kits of items illustrating such themes as historic trails, the gold rush, and the fur trade. He searched out the significant stories of the West that these artifacts—as well as the people who lived those stories—told. He extended his approach to teaching adult education courses at Central Oregon Community College.

Boyd approached The High Desert Museum founder Donald Kerr not long before the museum opened. "If you get to the point you want to expand into history, I'd love to help you out," he volunteered. Soon, he began the quarter-century moonlighting career as curator of western history, during which he researched and developed permanent and temporary exhibits that told myriad stories about Native American life, Euro-American exploration and settlement, the region's Hispanic, Chinese, and Basque heritages, the buckaroos and others who worked the land, as well as forest rangers and others who conserved and protected the land's resources. There are stories of frontier art, medicine, transportation, and life in general.

Both in the classroom and at the museum, Boyd made his indelible mark as a historian of the American West. He retired from The High Desert Museum in 2012 but continued his middle school teaching career. (Courtesy of the *Bulletin*.)

Jay Bowerman, Amphibian Researcher
Born in 1942 in Seattle, Washington, Jay Bowerman
grew up in Eugene, Oregon, a son of legendary
University of Oregon track coach Bill Bowerman.
After earning bachelor of science and master of
science degrees in science, serving as a US Army
officer, skiing and shooting his way to the US biathlon
championship in 1969, and competing for the United
States at the 1972 Winter Olympics, Bowerman
settled in Bend and has been a guiding spirit of the
Sunriver Nature Center for over 30 years.

As the nature center's principal researcher,
Bowerman's focus is amphibian research. He has
authored a number of scientific papers on topics
related to declining amphibian populations, amphibian
deformities, and the ecology of the Oregon spotted
frog. He is also affiliated with the University of
Oregon's Museum of Natural and Cultural History and
played banjo and guitar and sang with Bend's popular
Quincy Street Quartet. (Both photographs courtesy
of Sunriver Nature Center and Roger Ager.)

CHAPTER SEVEN

Lumbermen and Foresters

Within five years of the Oregon Trunk Railroad's arrival in Bend in 1911, a great increase in logging was needed to supply wood to the new Brooks-Scanlon and Shevlin-Hixon sawmills on opposite sides of the Deschutes River. Before those mills were built and opened, several small sawmills provided lumber to local markets.

Both the Brooks-Scanlon and Shevlin-Hixon companies acquired extensive timberlands as a result of the timber rush. The two mills were designed to cut a million board feet of timber each day between them. To sell that much lumber, they had to reach customers throughout the United States and Europe. World War I made for a brisk international lumber market between 1914 and 1918. By 1920, timber town Bend's population had grown from about 500 in 1910 to over 5,000.

Within that decade, these and other companies' private timber holdings were largely cutover. They turned to the Deschutes National Forest for trees to sustain their production and the area's economy. The General Exchange Act of 1922 allowed the companies to exchange their cutover timberlands—which were incorporated into the national forest—for rights to cut national forest timber under US Forest Service supervision. As a result, by the late 1930s, the Deschutes National Forest had grown by over 350,000 acres—almost a quarter of its current total acreage—on which the Forest Service helped new forests grow.

Cooperation between private lumber companies and federal foresters—some of whom were and are legendary locals—let Bend thrive as a timber town for decades. In 1950, Brooks-Scanlon bought out Shevlin-Hixon. By the 1990s, reduced availability of national forest timber, resulting from environmental concerns, spelled the end of Bend's timber economy. The last of Bend's sawmills cut their last logs into boards in 1995. Bend was no longer a timber town.

But the area's forests contain other resources that sustain life, lifestyles, and livelihoods in Bend, in Deschutes County, and throughout the nation. Water has always been the most vital forest resource. Around 70 percent of the water used in homes, industry, and agriculture in the western United States—and all of Bend's water—comes from forested watersheds. National forest rangelands have supported cattle and sheep grazing since settlement; however, economic and environmental factors have reduced grazing in recent decades. For more than a century, well-managed forests provided habitat for wildlife important to early hunters and trappers and modern recreational hunters and fishers. Recreation resources on the Bend-based Deschutes National Forest—including Oregon's largest winter sports area, resorts and campgrounds along scenic highways, and wilderness expanses—are essential factors in Bend's attractiveness to residents and its economy.

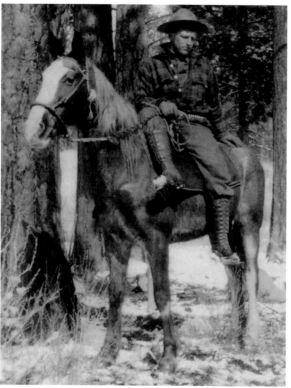

Harold E. Smith, Pioneer Forest Ranger (ABOVE)
Born in 1886 in Curry County, Oregon, Harold E. Smith
was a logger, miner, and trapper before being appointed a
US Forest Service ranger on July 1, 1911, for the old Paulina
National Forest, later included in the Deschutes National
Forest. Smith lived the rugged life of an early ranger, east
of Bend, for seven years. He continued his career in Alaska,
where he retired as deputy regional forester in 1945. He died
in 1987 in Berkeley, California. (Courtesy of Steve Petit.)

John Riis, Pioneer Forest Ranger (RIGHT)
John Riis, son of famous journalist Jacob Riis, was born in 1882
in The Bronx, New York. He went west in 1902 and joined
the new US Forest Service in 1907. After serving national
forests in Utah and California, he arrived in Bend in 1911 to be
Deschutes National Forest district ranger at Big River. Riis later
left the Forest Service. He became a journalist, and his 1937 book
Ranger Trails immortalized his years in Bend. (Courtesy of John
Riis Group.)

Samuel A. Blakely, Logging Superintendent

Born in 1872 in New Brunswick, Canada, Samuel A. "Sam" Blakely (right) was a second-generation logger and the Brooks-Scanlon Lumber Company's first logging superintendent in Bend. He held the job for 31 years, during which he gained a nationwide reputation not only for his knowledge of logging but for his concern for forest conservation.

Blakely began his 43-year logging career with the company that became Brooks-Scanlon at its first mill in Nickerson, Minnesota, in 1900. As the *Bend Bulletin* reported on November 16, 1906, "Sam A. Blakely, who has been cruising timber for the [then] Scanlon-Gipson company during the summer, left Bend Thursday for Minnesota. He declared that he liked the Bend country very much and hoped to be able to return here with his family to establish his home."

In 1912, the company returned Blakely to Bend with his wife, Chrissie, whom he married in New Brunswick in 1899, and their sons, Gale and Loyde, who were born in Nickerson. Blakely laid the logging groundwork for the large ponderosa pine mill Brooks-Scanlon would open a few years later. The Blakelys built their first house on the outskirts of Bend on Greenwood Avenue near Fourth Street and later built a house at 504 Congress Street, which was home to three generations of the family before it was sold in 1953.

Blakely passed his knowledge of logging on to his sons, who also worked for the company. Gale began his career in the woods running compass for his father, while Loyde started as an office boy. After a year at Oregon State College, Gale "returned to the Brooks-Scanlon timber to take an advanced course under his father, one of the really great loggers of his time." Following his father's death in 1943, Gale assumed the logging superintendent job. As Stewart Holbrook wrote in 1947, "Gale Blakely, as nobody in Central Oregon needs to be told, is the bull of the woods of Brooks-Scanlon's ponderosa pine operation out of Bend, and the third generation logging boss in a notable logging family." Loyde graduated from college in 1926 and returned to Brooks-Scanlon to work in business management. He served on the Bend City Commission and the Oregon State Game Commission.

The logging careers of Sam Blakely and his sons spanned from logging with sleds and oxen to modern machine power and from living in remote camps to living in cities. (Courtesy Deschutes County Historical Society.)

John H. Meister, Logging Superintendent

John H. "Jack" Meister was logging superintendent for the Shevlin-Hixon Company during the 1920s and 1930s. Walter Perry, who as Deschutes National Forest chief lumberman from 1925 to 1932 worked regularly with Meister, wrote in 1937, "Meister knew logging from A to Z, and knew men from Z to A. He had an ever-present, droll, quizzical sense of humor that smoothed out many rough spots."

Perry recalled the time he helped Meister smooth out a rough spot in the woods. Shevlin-Hixon had bought and was cutting Deschutes National Forest "timber lying up against a flow of raw and extremely rough black lava. Three hundred yards across the lava was 'Hoffman Island," a timbered butte surrounded by the flow. We had Jack Meister up there, trying to convince him he could railroad across and get this timber. He shied at the probable cost. We said we thought it would be possible to get the stuff all right, and after a couple of contemplative puffs at his cigar he replied: 'Possible? Hell yes! It's possible. If the company would let me spend money enough I could take the whole damned island down to Portland and rebuild it!' He bought and cut the Hoffman Island timber—and the railroading across the spumey lava was not nearly as costly as it looked."

Meister and Perry enjoyed the mutual respect of capable woodsmen who knew their jobs and sustained both Bend's timber economy and the forest resource. Whenever a timber sale issue came up, they knew—as Perry put it— "we could best discuss it on the ground, and with Meister there was no need to feel on the defensive." (Courtesy of Deschutes County Historical Society.)

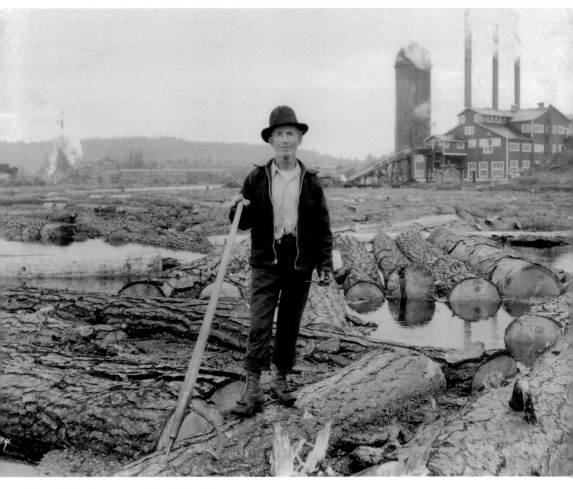

Dan J. MacLennan, Pond Monkey
Every time an 80-car train of logs was dumped into the Deschutes River at Bend for the Brooks-Scanlon mills, it was Dan MacLennan's job to herd those logs a mile downstream and make sure they did not pile up on the banks. Agile in corked boots, he did the job hopping from log to log with a peavey or pike pole. The peavey photographed above was used to push a log with the point or roll a log with the attached cant hook.

MacLennan was born in 1877 in a logging camp about 20 miles from Saginaw, Michigan, and left home at age 12 to work at logging himself. He spoke only pure Gaelic then, the language his parents taught him. He was 23 and a veteran of many spring log drives down the French River when he moved to the Pacific Northwest.

After a decade running shingle camps in Washington, MacLennan moved to Bend and worked in the woods until Brooks-Scanlon's first mill opened and needed a pond monkey. He had only one bad accident in all the time he worked for Brooks-Scanlon; a load of logs once started down on him before he was ready. He took to the river to save himself, but the logs caught up with him and crushed him badly. However, he was back on the job in a few weeks.

During all his life in the wild and rough days of logging, MacLennan never took an alcoholic drink of any kind. (Courtesy of Deschutes County Historical Society.)

Walter J. Perry, Forester

As their private timberlands were cutover, Bend's lumber companies turned to the Deschutes National Forest to sustain their production and the city's economy. In 1925, the US Forest Service transferred Walter J. "Walt" Perry, a forester with a forward-looking timber management ethic, from the Carson National Forest in New Mexico to Bend. As chief lumberman, he managed timber sales and logging operations in the national forest. The General Exchange Act of 1922 allowed the lumber companies to trade cutover private timberlands, incorporated into the national forest, for rights to cut national forest timber under Forest Service supervision.

Perry was born in Kansas in 1873, grew up in Texas, and worked at many jobs—most notably mining and logging in Mexico—before finding his "real life's work" in the Forest Service. He served on national forests in New Mexico and Oregon from 1910 to 1936 as a forest guard, assistant forest ranger, forest ranger, scaler, lumberman, senior lumberman, and chief lumberman. He was not a forestry school graduate; his formal education ended with the third grade. Essentially self-educated, he became a senior member of the Society of American Foresters and a respected member of the forestry profession.

Perry earned that respect. He received his Deschutes National Forest appointment by supervising the big Hallack and Howard Lumber Company sale on the Carson National Forest for eight years. Decades later, a forester who assisted him paid homage to that supervision by observing that "the timber has grown up and it's hard to see where that big operation was carried on." Perry enjoyed similar success with the Deschutes National Forest, where his management helped establish and maintain healthy second-growth ponderosa pine forests on national forest lands as well as on previously private cutover lands added to the national forest.

Among his many avocations, Perry was an accomplished amateur archaeologist who facilitated a key finding in North American anthropology. "How much I and Far West prehistory owe to Walt!" anthropologist Luther Cressman wrote of Perry's major role in the 1938 Fort Rock Cave discovery that more than doubled estimates of how long humans had lived in the Great Basin and the Northwest and put Oregon prehistory on the map.

Perry, a rough and ready gentleman of intelligence and integrity, died in Bend in 1959. His memoirs and papers were edited into *Walt Perry: An Early-Day Forest Ranger in New Mexico and Oregon*, published in 1999. (US Forest Service photograph by Carl Neal courtesy of the WJP Group.)

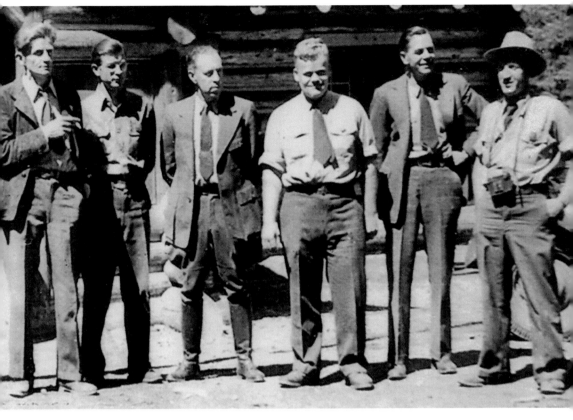

Forest Supervisor Ralph W. Crawford and Rangers
Deschutes National Forest supervisor Ralph W. Crawford (third from left) was photographed in 1943 at Skyliner Lodge with his district rangers and fire control officer. From left to right are Henry Tonseth, district ranger, Fort Rock Ranger District; Harold Nyberg, district ranger, Sisters Ranger District; Homer Oft, district ranger, Crescent Ranger District; Gail Baker, fire control officer; and Joe Lammi, district ranger, Bend Ranger District.

District ranger Tonseth, who ran the Fort Rock Ranger District—headquartered at Cabin Lake Ranger Station until 1945, then in Bend—from 1934 to 1969, established and still holds the Pacific Northwest Region record for longevity in one district ranger assignment.

District ranger Lammi was the 30-year-old Bend district ranger when the US Army Corps of Engineers built the Camp Abbot combat engineer training center on his district in 1943. He had bachelor's and master's degrees in forestry from Oregon State College and worked closely with senior Army officers as the World War II training center was built. That fall, Joe joined the Army. Bidding family and friends farewell, Private Lammi thought he was off to see the world but was assigned to Camp Abbot for training. "Same old trees, same old hills, but a different uniform!" he was teased.

"I went in as a buck private," Lammi said, "and I retired as [a] major." After training at Camp Abbot, he was commissioned and saw combat in North Africa and Italy. "I had my own jeep and driver. My job was to tour the front and make sure the ammunition, weapons, and other equipment were in the right places at the right times."

When the war ended, Lammi returned to the US Forest Service. During the early 1950s, he earned a PhD in forest economics at the University of California at Berkeley. He then worked for the United Nations Food and Agriculture Organization in Geneva before becoming a professor of forestry at North Carolina State University. Born in San Francisco in 1913 to Finnish immigrants, Lammi retired in 1979 and died in 2003. (Courtesy of Deschutes County Historical Society.)

Wilmer Roy Van Vleet Jr. and Leonard Peoples, Boy Smokechasers
World War II depleted manpower resources, and the US Forest Service turned to high school boys to help staff fire lookouts and fight forest fires. Among those assigned to the Deschutes National Forest were Bend High School students Wilmer Van Vleet Jr. (in uniform next to his car), son of Bend's leading photographer, and Leonard Peoples (in his car at a national forest guard station), brother of US Army Air Forces fighter pilots Sam and Phil Peoples.

Peoples delighted in telling the story of the day he spotted smoke from the Wanaoga Butte Lookout 16 miles southwest of Bend and reported its azimuth to the fire dispatcher. Needing a cross-fix to locate the smoke, the dispatcher told Peoples to drive to the unmanned Fuzztail Butte Lookout 13 miles south-southeast of Bend to shoot a second azimuth. The location of the fire pinpointed, the dispatcher needed a firefighter, so he sent Peoples. (Left, courtesy of Deschutes County Historical Society and Laura Goetz; right, courtesy of Laura Goetz.)

Hans Milius, Forester

Hans Milius (right) served most of his 39-year career as a professional forester in government service and private industry in Bend before he reached his employer's mandatory retirement age of 65 in 1976. Born on October 25, 1911, in Romania, where his father was a papermaker, young Hans and his mother spent World War I in Germany with his grandparents; his grandfather was a German woodlands owner and sawmill operator. Following his father's work, his family traveled to various other countries after the war and came to the United States in 1927. Milius finished high school, graduated from the University of Wisconsin with a degree in chemical engineering, and then earned a master's degree in forestry at Iowa State College.

Milius joined the US Forest Service and worked on the Columbia National Forest (now the Gifford Pinchot National Forest) in Washington State until he was transferred to the Deschutes National Forest headquarters in Bend, where he served as timber sale officer until 1950. He then went to work for the Brooks-Scanlon Company as one of the early graduate foresters to work for a small-to-medium sized lumber company. He stayed there for 26 years until company policy forced him to retire in 1976. He continued in private practice as a forester and died in Bend on May 28, 1998.

Throughout his career, Milius found management of Central Oregon forests lacking. Most of the national forest timber sales around Bend were made on an exchange basis as authorized by the General Exchange Act of 1922 under which lumber companies traded cutover private lands for logging rights on the national forest. He urged the practice of intensive forestry on both private and public forestlands. Without such forest management, he claimed in an April 1952 speech before the Bend Rotary Club, the 8.5 billion board feet of timber on which Bend's timber-based economy depended would be depleted in another 50 years. (Courtesy of Deschutes County Historical Society.)

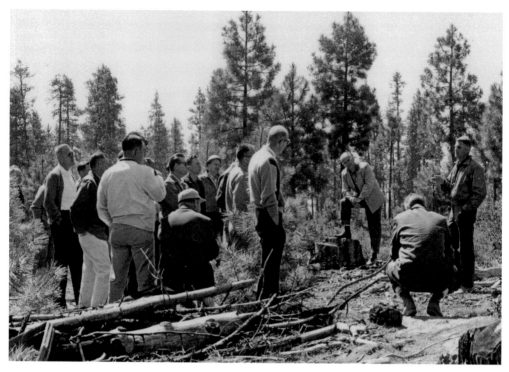

James W. Barrett, Research Silviculturist

James W. "Jim" Barrett (right) of Bend deserves the title "Mr. Ponderosa Pine" for the results of his decades of research on propagation of Central Oregon's primary timber source.

Barrett, the son of a doctor, was born on June 26, 1922, in Independence, Iowa, and graduated from high school there in June 1940. He volunteered for military service during World War II but—at the US Marine Corps officer training school at the University of Notre Dame—he was found not physically qualified for military service and discharged. Barrett earned a bachelor of science degree in forestry in 1945 and a master of science degree in forest management and forest pathology in 1947, both at Iowa State University.

After ranching in South Dakota for several years, Barrett moved to Oregon in 1956, joined the US Forest Service, and worked as a Deschutes National Forest timber marker and cruiser. He began his Pacific Northwest Forest and Range Experiment Station (later the Pacific Northwest Research Station) career in 1958 at the Pringle Falls Experimental Forest, of which he was put in charge that year, within the Deschutes National Forest. He spent the next 24 years there and at the Bend Silviculture Laboratory in research focused on ponderosa pine propagation. Early in those years, even as he managed the experimental forest and assisted with other studies, Jim began three long-term ponderosa pine studies that spanned his career.

Barrett married Deschutes Research Center clerk-stenographer Helen Rastovich, who joined the Forest Service after graduating from Bend High School in 1943. Barrett soon became a leader in ponderosa pine silviculture, and in December 1979, the Pacific Northwest Research Station published his text *Ponderosa Pine in the Pacific Northwest: The State of Our Knowledge* as a reference for forest managers. Barrett also passed on what he learned to agency and industry forest managers and university students during "show me" trips and classes at Pringle Falls Experimental Forest and other field sites. Barrett retired from the Forest Service in 1982 but remained active in ponderosa pine research for many years. He and his wife remained Bend residents. (Courtesy of Bureau of Indian Affairs.)

Walt Schloer, Forest Ranger
Walt Schloer was "Bend's forest ranger" for almost a quarter of a century. He arrived at the Deschutes National Forest in March 1980 to take the reins of its Bend Ranger District, one of the forest's two districts headquartered in Bend. In 1995, when the Bend and Fort Rock Ranger Districts were merged, he became ranger of the million-acre Bend-Fort Rock Ranger District, which he led until he retired in January 2005. (Photograph by Les Joslin.)

Robin Lee Gyorgyfalvy, Landscape Architect
Shown in the field with packer Jim Leep (left) and pack mule Charlie, Hawaiian native and US Forest Service landscape architect Robin Lee Gyorgyfalvy (right) holds a master's degree in landscape architecture from the University of Oregon and is a fellow of the American Society of Landscape Architects. She has applied her professional skills to benefit the Deschutes National Forest since 1987. (Photograph by Les Joslin.)

Leslie A.C. Weldon, Forest Supervisor

Leslie A.C. Weldon served as forest supervisor of the Bend-based 1.6-million-acre Deschutes National Forest for seven years from 2000 to 2007. Born into a US Air Force family in Pullman, Washington, Weldon grew up overseas and in several states. She developed a love of the outdoors and wildlife in an on-base Girl Scout troop in Japan. She pursued those interests as a high school Youth Conservation Corps enrollee in southwestern Virginia and, in 1983, earned a bachelor's degree in fisheries and wildlife biology at Virginia Polytechnic Institute and State University (Virginia Tech) in Blacksburg.

Weldon began her US Forest Service career in 1981 as a summer hire, monitoring seedlings, fighting wildfires, and surveying spotted owls on the Mount Baker-Snoqualmie National Forest in Washington. In 1983, she became a fisheries biologist there for three ranger districts. After additional biologist assignments, she served as assistant district ranger and district ranger on the Stevensville Ranger District of Bitterroot National Forest, Montana, from 1992 to 1996. From mid-1996 to 1998, she was Forest Service liaison to the US Army Environmental Center at Aberdeen Proving Ground, Maryland, and from 1998 to 2000, she was executive policy assistant to Forest Service chief Mike Dombeck in Washington, DC. From there, she, her husband, and two sons moved to Bend, where as Deschutes National Forest supervisor she was responsible for the management of the forest's natural resources, business operations, and public services.

After another stint in Washington, DC, Weldon served from 2009 to 2011 as regional forester for the Northern Region of the Forest Service. In this position, she oversaw the management of 28 million acres of national forests and grasslands as well as other agency programs in northern Idaho, Montana, and North Dakota. In November 2011, she was named deputy chief of the Forest Service for the National Forest System; she was the lead executive responsible for policy, oversight, and direction of natural resource management programs on the 193-million-acre National Forest System.

During her seven years in Bend, Weldon was deeply involved in community affairs and served on several boards and with several organizations, including The High Desert Museum, Rotary International, United Way, and the Oregon Museum of Science and Industry. (Courtesy of Oregon Forest Resources Institute.)

CHAPTER EIGHT

Soldiers, Sailors, Airmen, and Marines

The beautiful Bend Heroes Memorial on the Deschutes River bears witness to the price of freedom. Bend servicemen and servicewomen have served in World War I, World War II, the Korean War and Vietnam War components of the Cold War, the Persian Gulf War, and the Afghanistan-Iraq War, as well as other combat operations. This service has produced many more legendary locals than this chapter can do justice. A few more, recognized in the following paragraphs, reflect the many.

Charles A. Nickell owned the Wind Mill Billiard Parlor at 855 Wall Street before World War I. When the United States entered the conflict, he locked the doors to go to war. He served in the US Army's famed 42nd Infantry Division (the "Rainbow Division") and was wounded in action in France and decorated for bravery. Upon his return to Bend, he and his wife, Daisy, operated the Hippodrome at 645 Wall Street. He was one of many Bend citizens who served in World War I.

World War II called many Bend men and women to service in the armed forces. As profiles in this chapter relate, many became Army Air Forces and Navy pilots. At least one of these pilots served in combat again during the Korean War. Many veterans of the Vietnam War are Bend natives or immigrants.

Chief Engineman Donald L. McFaul, a 1975 Bend High School graduate, was a US Navy SEAL killed in action on December 20, 1989, during Operation Just Cause in Panama. He was posthumously awarded the Purple Heart and Navy Cross for heroism in combat while pulling another SEAL to safety. The *Arleigh Burke*–class destroyer USS *McFaul* (DDG-74) was named in his honor.

Master Chief Gunner's Mate John P. Spence, who retired from the US Navy in 1961, settled in Bend in the early 21st century after the death of his wife. Spence served in covert underwater warfare with the Office of Strategic Services (OSS) during World War II and is recognized as the Navy's first frogman, predecessor of the Navy SEALs. He died in Bend on October 29, 2013, at the age of 95.

Bend residents also served on the home front. After the United States entered World War I in 1917, Bend and the rest of the nation faced severe labor shortages as young men were called into the armed forces and other workers were required by defense industries. As a result, crews of women worked in Bend's sawmills then, just as their daughters—characterized as "Rosie the Riveter"—worked in defense industries and other jobs during World War II.

Also during World War II, Bend pitched in to help build and operate Camp Abbot, a US Army Corps of Engineers training center on the Deschutes River south of Bend at which about 90,000 combat engineers trained in 1943 and 1944.

Robert Dale Maxwell, US Army Medal of Honor Recipient

Robert Dale "Bob" Maxwell, shown at the September 11, 2004, dedication of the Robert D. Maxwell Veterans Memorial Bridge across the Deschutes River south of Bend, received the Medal of Honor for heroism in combat during World War II. On October 22, 2013, at the age of 92, the only living Medal of Honor recipient in Oregon, Maxwell became the oldest living World War II Medal of Honor recipient.

Maxwell was born on October 26, 1920, in Boise, Idaho. Raised in a Quaker farm family, Maxwell doubted he should serve. Conscription solved that problem. After initial action in North Africa, he was awarded a Silver Star Medal for valor and a Purple Heart for combat wounds at the assault at Anzio, Italy. Technician Fifth Grade Maxwell recovered in a Naples hospital in time to rejoin his unit—the 3rd Battalion, 7th Infantry Regiment, 3rd Infantry Division—for the August 1944 invasion of southern France.

On September 7, 1944, near Besancon, France, Maxwell and three fellow soldiers were establishing communications at a battalion observation post. Suddenly, they were overrun by a platoon of German infantrymen. Armed only with a .45 caliber pistol, Maxwell fought off the enemy and inspired his fellows. An enemy hand grenade was thrown in the midst of Maxwell's squad. Unhesitatingly, Maxwell hurled himself upon it, using a blanket and his unprotected body to absorb the full force of the explosion. Seriously wounded, he saved the lives of his three fellow soldiers.

Maxwell recovered and, later in 1944, was decorated with a second Silver Star, a second Purple Heart, and a Bronze Star awarded with the Combat Infantryman's Badge. On April 6, 1945, Maxwell was awarded the Medal of Honor, the nation's highest military decoration. France decorated him with the Croix de Guerre for heroism and the Legion d'honneur, the highest decoration France can bestow.

After the war, Maxwell and his wife, Beatrice, moved to Oregon. He wound up teaching auto mechanics at Bend High School, then Central Oregon College (before it became Central Oregon Community College), and then Lane Community College in Eugene, which awarded him an honorary degree and named its student veterans center in his honor. In 1970, he was lauded as one of the Outstanding Educators of America. In 2011, Maxwell received his high school diploma from Bend Senior High School. (Courtesy of Lt. Col. Dick Tobiason.)

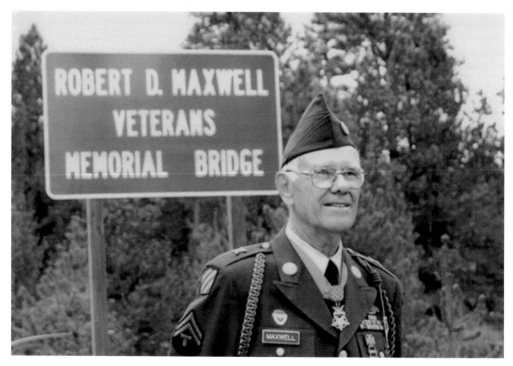

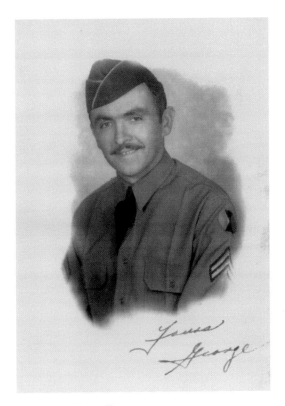

George A. Mirich, "One-man Army"

On the morning of May 26, 1943, on the cold, windswept island of Attu in the Aleutian chain of Alaska, 28-year-old Cpl. George W. Mirich—a 1935 Bend High School graduate—avenged a friend and became a hero.

The citation awarding Mirich the Distinguished Service Cross, second only to the Medal of Honor, reads as follows:

> When his battalion was advancing on Japanese-held Chichagof Pass, Corporal Mirich, a company clerk, at his own request was acting as leader of a rifle squad. His company met intense fire from commanding enemy positions above the line of attack and progress was slowed. Alone and on his own initiative, Corporal Mirich moved around the flank, and climbed a steep precipitous incline to reach the Japanese entrenchments. With rifle fire and grenades he cleaned out five enemy foxholes. His gun jammed. He then used his bayonet until it was broken. Corporal Mirich without hesitation continued the attack, using only his rifle butt. His infinite courage and skill in executing the attack and liquidation of the enemy strong point enabled his platoon to advance and mop up surrounding enemy positions.

Seven dead enemy soldiers, including one of Mirich's close friends, lay in his wake. "Later in the day, as he led his squad in assaulting a hill dominating the pass, Corporal Mirich was wounded," the citation continues. For the three bullet wounds in his arm and his skilled bravery, Mirich received the Purple Heart. His battalion commander promoted him to sergeant on the spot. Hailed as "the one-man Army of the Attu campaign," Sergeant Mirich was assigned to war bond rallies and morale boosting tours throughout the United States.

Mirich returned to Bend after the war to operate the Mobil gas station then on the corner of Bond Street and Franklin Avenue. He died in a car wreck in 1965. (Courtesy of Deschutes Pioneer Association and Ryder Graphics.)

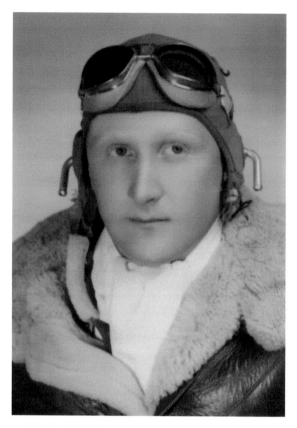

Jim Byers, US Army Fighter Pilot

A member of the Bend High School class of 1941 and captain of the Lava Bears's first and only state championship football team, Jim Byers was a prize recruit of the University of Washington football team. However, the December 1941 attack on Pearl Harbor changed many lives, and by 1943, Byers was a US Army Air Forces pilot.

On the morning of D-Day, June 6, 1944, 20-year-old Lieutenant Byers was pushing his P-38 Lightning at 290 miles per hour just 50 feet above the surf of Utah Beach. He and 22 other pilots were closing on a target that was the key to the success—and the survival—of the Allies soon to hit that beach. Just six miles inland, the Germans had 24 mammoth railway guns directed at the landing forces. A mile from the target, Byers's formation was slammed by German antiaircraft fire. His flight leader and wingman went down in flames, but he and the others pressed the attack. Twenty minutes later, 23 of the 24 German guns had been knocked out and odds improved for American infantrymen landing on Utah Beach.

Byers flew back to England and handed his P-58 over to his brother Lt. Bill Byers, who flew the second mission. Each brother flew a second mission in the same plane that day, then each flew a third, attacking German tanks and supporting infantry. The two Byers brothers and the rest of the attack force again returned to England. In later 1944 air combat, Byers earned the prestigious Distinguished Flying Cross for bravery.

In all, Jim Byers flew 68 combat missions in Europe before returning to Bend. But his civilian life did not last very long. He was soon called back into the US Air Force for the Korean War, in which he flew an even 100 missions in P-51 Mustangs. He was living in Portland when he died in 2000. His brother Bill died in 1978. In September 2010, in recognition of service to his country in two wars and for leading his Bend High School football team to the school's only football state championship, Byers was inducted into the Bend High School Hall of Fame. (Courtesy of Deschutes Pioneers Association and Ryan Graphics.)

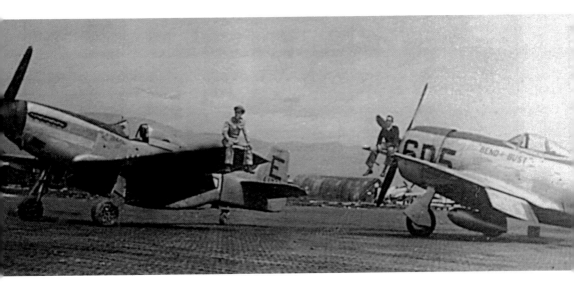

Sam and Phil Peoples, US Army Fighter Pilots
US Army Air Forces lieutenants Sam and Phil Peoples met up in 1945 in Pisa, Italy, with their fighter aircraft. Sam flew the p-51 Mustang (above left), and Phil flew the P-47 Thunderbolt (above right), which he named "Bend-er-Bust" (below). The brothers graduated from Bend High School two years apart but enlisted together in 1942. After flight training, both were commissioned as second lieutenants and flew combat missions based in Italy. Sam, in his P-51 Mustang, escorted bombers into Germany and Romania; Phil, in his P-47, provided air cover for Allied forces advancing through northern Italy.

The brothers were sons of Ray Peoples, a manager at the Shevlin-Hixon Mill in Bend, and Mabel Lorence, a Bend teacher from 1915 to 1919. After the war, the brothers earned degrees at Oregon State College in Corvallis and pursued successful careers at Boeing in Seattle. Sam died in 1995; Phil lives with his wife, Robbie, in Bend. (Both photographs courtesy of Phil Peoples.)

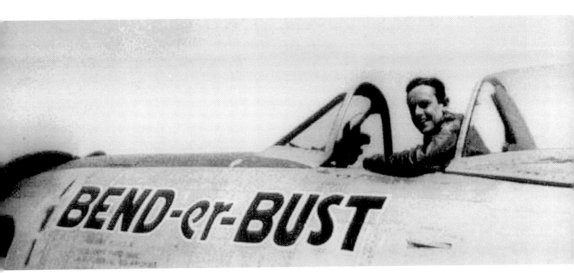

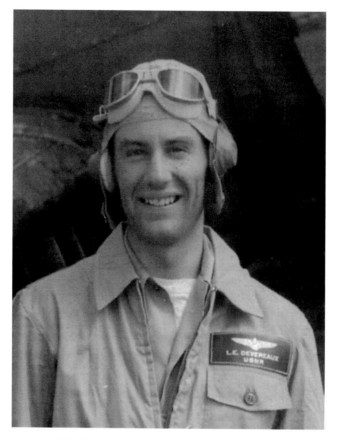

Leon E. Devereaux Jr., US Navy Aviator

A son and grandson of Central Oregon pioneers, Leon E. Devereaux Jr., was born in Bend in 1923 and graduated from Bend High School in 1941. On December 7, 1942, the first anniversary of the Japanese attack on Pearl Harbor, Devereaux joined the US Navy and left Oregon State College in Corvallis to attend Navy flight training as an aviation cadet. He was commissioned an ensign and designated a naval aviator in July 1944.

Ensign Devereaux was soon flying the F-4U Corsair in combat missions off aircraft carrier USS *Shangri-La.* On July 14, 1945, during an air battle off southern Hokkaido, he shot down a two-engine Japanese G-4M "Betty" aircraft. As he landed aboard the carrier, his plane's tail hook failed. Uninjured in the demolished plane, he was told to report to the flag bridge. Adm. John S. McCain, task force commander, commented on his crash landing: "That's one for one, eh?"

Devereaux flew combat air patrol over battleship USS *Missouri* in Tokyo Bay during the September 2, 1945, signing of the Japanese surrender document that ended World War II. With over 40 combat missions and three air medals to his credit, he was released from active duty in 1946. Several years later, flying as a ready reservist, he was promoted to lieutenant, junior grade.

Devereaux returned to Bend and married Marian Louise Mowery in 1946. They had three children. He first worked as a draftsman for Pacific Power and Light Company, then as Brooks-Scanlon Lumber Company controller, and finally for Diamond International Corporation, from which he retired in 1984 as purchasing manager. He served on the Bend city commission and, in 1968, became mayor of Bend, which was then a city of 13,000. He was twice president of the Deschutes Pioneers Association and served on the Deschutes County Historical Society Board of Directors. An active member of Elks Lodge No. 1371 in Bend since 1946, Devereaux was named its Veteran of the Year for 2013–2014. (Courtesy of Leon Devereaux.)

Helen Marie Skjersaa, Women's Air Service Pilot

"Helen Marie Skjersaa, 22, daughter of Mr. and Mrs. L.N. Skjersaa of 115 Riverfront St., received her silver wings Dec. 17 . . . at Avenger Field, Sweetwater, Texas, as a member of the Women's Air Service pilots—the Wasps," the *Bend Bulletin* reported in late December 1943. A Bend High School graduate with three years of college, Skjersaa (Hansen after she married in 1945) ferried US Army Air Forces planes during World War II. (Courtesy of Bill Mayer Jr.)

Dick Tobiason, US Army Aviator and Veterans Advocate

Lt. Col. Dick Tobiason, a retired US Army master aviator, is Bend's leading armed forces veterans' advocate. Born in 1935 in Boston, Massachusetts, he graduated from Northeastern University in 1957 and was commissioned a second lieutenant. During his 20-year Army career, Tobiason flew fixed and rotary wing aircraft in combat, graduated from the US Navy Test Pilot School, and was nominated for the Apollo astronaut program. (Courtesy of Lt. Col. Dick Tobiason.)

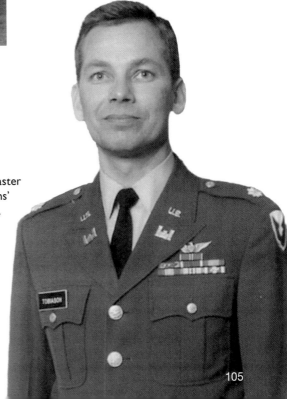

105

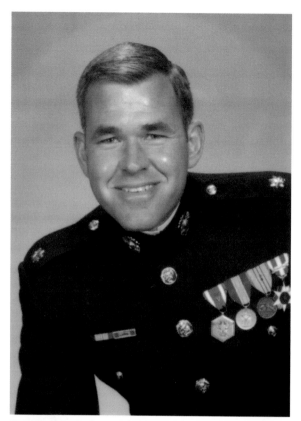

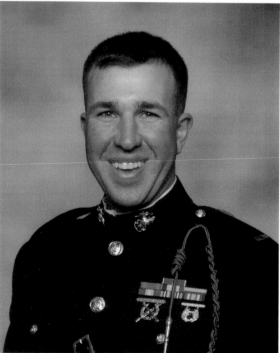

Mike Brock and Casey Brock, US Marine Corps Officers
A 1962 graduate of Lakeview High School, Col. Mike Brock (above, as lieutenant colonel) graduated from Southern Oregon College in 1966 and was commissioned a second lieutenant in the US Marine Corps. His over 26 years of active duty included assignments as a platoon commander in Vietnam, a group commander in Saudi Arabia, and an intelligence officer in Somalia before he retired in Bend in 1994. Brock served as Bend area Navy Junior Reserve Officer Training Corps instructor at Mountain View High School from 1994 to 2005.

A 1996 graduate of Mountain View High School, Maj. Casey Brock (below, as first lieutenant) earned a biology degree at Oregon State University and, following in his father's footsteps, was commissioned a second lieutenant in the US Marine Corps in 2001. He led Marines in combat in Iraq, served in special operations, and received the Marine Corps Association's 2011 Leftwich Trophy for outstanding leadership. (Both photographs courtesy of Col. Mike Brock.)

**Randy L. Newman,
US Marine Corps**
L.Cpl. Randy L. Newman was born in Bend in 1985 and graduated from Mountain View High School in 2003. A year later, he joined the US Marine Corps and served with the 3rd Light Armored Reconnaissance Battalion, 1st Marine Division, I Marine Expeditionary Force at Twentynine Palms, California. He was killed in combat in Iraq on August 20, 2006. (Courtesy of Jerry and Ramona Newman.)

Zachary W. McBride, US Army
Sgt. Zachary W. McBride, born in New York City in 1987, moved to Bend in 2003 with his family from Oak Harbor, Washington, and graduated from Mountain View High School in 2005. Serving in the 2nd Stryker Cavalry Regiment, he died in Sinsil, Iraq, on January 9, 2008, of wounds sustained when an improvised explosive device detonated during combat operations. (Courtesy of Laurie McBride.)

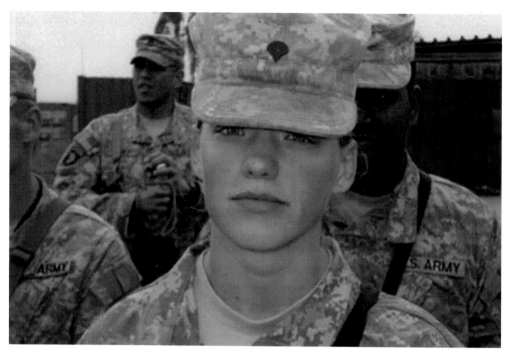

Jessica Ellis, US Army
Cpl. Jessica Ellis was born in 1983 in Burley, Idaho, and graduated in 2002 from Lakeview High School in Lakeview, Oregon. She attended Central Oregon Community College in Bend for two years, working summers as a US Forest Service firefighter. A combat medic on her second tour in Iraq, she died on May 11, 2008, when an explosively formed penetrator destroyed the armored vehicle in which she was riding. (Courtesy of Lt. Col. Dick Tobiason.)

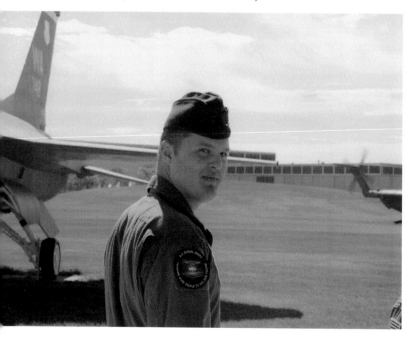

Justin J. Wilkens, US Air Force
1st Lt. Justin J. Wilkens was born in Bend in February 1986, homeschooled, and commissioned upon graduation from the US Air Force Academy in 2009. "An outstanding junior officer/aviator," he was serving his third deployment with the US Air Force 34th Special Operations Squadron when, on February 18, 2012, his U-28 aircraft went down in Djibouti, Africa. (Courtesy of Jim and Sharon Wilkens.)

CHAPTER NINE

Artists, Writers, Entertainers, and Visionaries

An entire book could be written about Bend artists, writers, and entertainers. Only eight local legends of this vast field are profiled in this brief chapter; a few more are mentioned in this introduction.

Many artists are inspired by western landscapes and lifeways. Margaret A. Merritt was a professional artist who operated her own studio in Bend for more than 30 years. A charter member of the Sage Brushers painting group, she specialized in oils and watercolors of juniper trees as well as desert and mountain scenes. International artist Jennifer Lake, best known for her detailed folk art paintings, has called Bend home. A professional artist for over 30 years, Lake is the most collected artist in the Northwest. Many landscape photographers are also based in Bend.

The scion of a New York publishing family and early editor and publisher of the *Bulletin*, young George Palmer Putnam also may have been Bend's first novelist. Published in 1918 by G.P. Putnam's Sons, his novel *The Smiting of the Rock* about a young newspaperman in frontier Farewell, Oregon, is thinly disguised autobiographical fiction. More recent Bend literary lights include writers Jane Kirkpatrick and Ellen Waterston. Born in Wisconsin, Kirkpatrick moved to Oregon in 1974 after completing a master's degree in social work, and she became director of the mental health program in Deschutes County. An award-winning writer whose historical novels focus on the of the lives of Western women, she is the author of over 25 books—most written at a John Day River homestead in a remote part of Oregon. She and her husband returned to Bend to live in 2010. Massachusetts-born Bend resident Waterston is an award-winning poet, author, and literary arts advocate who founded and directed the Nature of Words, a literary arts nonprofit, and her Writing Ranch for sharing writing with others.

Since retired Klondike Kate settled there and future movie star Clark Gable briefly worked in its sawmills, Bend has contributed several names to the performing arts and the entertainment industry. A 1968 graduate of Bend High School, Pat Cashman made his name as a comedian and television and radio personality. A 1988 graduate of Bend High School, Lonnie Chapin took his talent to Nashville and played in a band that won a 2001 Grammy Award before he returned to Bend to launch a new radio station. A 1998 graduate of Mountain View High School, Shannon Bex is an American singer, dancer, and member of the musical group Danity Kane. Another young Bend woman, Sara Jackson-Holman, enjoys national success as a singer-songwriter.

A local theater legend, Carol Bryant acted and directed in, promoted, and shepherded the Community Theater of the Cascades (renamed Cascade Theatrical Company) from its early shows in the Kenwood School gym to its Greenwood Playhouse. Bryant's last performance as an actor on a Bend stage was at the Second Street Theater, just a few years before her 2011 death.

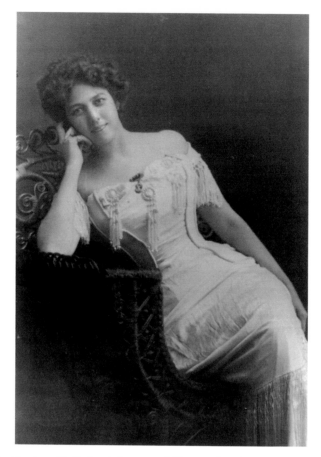

Kathleen Eloisa Rockwell, Entertainer and Humanitarian

Kathleen Eloisa Rockwell loved the stage life. She performed in New York and Seattle, and in 1898, she was drawn to the Yukon Gold Rush, where she gained notoriety for her flirtatious dancing and ability to keep hard-working miners happy if not inebriated. There, the young entertainer became known as "Klondike Kate" since miners were her devoted fans. For a time, she was a celebrity.

Rockwell's road to Bend was a rocky one. She was born in Kansas in 1873 and grew up in Spokane. Her family sent the rebellious teenager to boarding school, and she was expelled. Hard times split the family, and she moved with her divorced mother to New York for an unsuccessful attempt at show business. She moved on to the Yukon in 1899, had an intense love affair with future vaudeville impresario Alexander Pantages, who jilted her, and moved on to pine her loss and perhaps forget him.

Rockwell arrived in Bend in 1914, homesteaded three miles north of Brothers, Oregon, in 1917, was briefly married to a cowboy named Floyd Warner, proved up on her claim, and sold out. She returned to Bend and built a house at 231 Franklin Avenue. "Aunt Kate" became known as a true humanitarian, whether providing a pot of stew or coffee to "gentlemen of the road," bringing coffee and doughnuts to Bend's firefighters, or caring for the sick during the 1918 influenza pandemic. She married again, this time to an old sourdough named Johnny Matson from her early days who spent much of their married time prospecting in the Yukon until he died.

Rockwell lived in Bend until 1948 and then married old friend Bill Van Duren and moved to Sweet Home, Oregon. On December 23, 1954, Kate Van Duren appeared on the television quiz show *You Bet Your Life*, hosted by Groucho Marx. She died in 1957. Rockwell was philosophical about her life of success and failure: "When you think your heart is breaking, mush on and smile. When you feel you've been forsaken, mush on and smile." (Courtesy of Deschutes County Historical Society.)

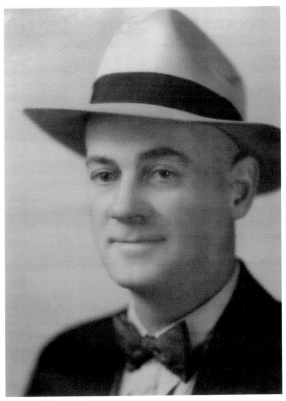

Paul Hosmer, Writer and Photographer

Born in Minnesota in 1887, Paul Hosmer arrived in Bend in 1915 to serve as a stenographer in the newly opened Shevlin-Hixon Company office. But in 1920, after serving as a US Army first sergeant in World War I, Hosmer won acclaim as editor of *Pine Echoes*, the Brooks-Scanlon Company house organ, for 41 years. In 1962, about six months after his death, Mud Lake (near Elk Lake) was renamed Hosmer Lake in his honor. (Courtesy of Deschutes County Historical Society.)

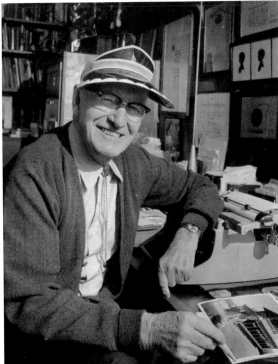

Philip F. Brogan, Journalist and Geologist

Philip F. "Phil" Brogan was born in 1896 east of the Cascades in The Dalles, Oregon, and raised in the Ashwood area of Central Oregon. He served in the US Navy in World War I and studied journalism and geology at the University of Oregon. He moved to Bend in 1923, worked as a reporter on the *Bend Bulletin* until 1967, and told the region's story in his 1964 book *East of the Cascades*. Brogan died in May 1983 in Denver. (Courtesy of Deschutes County Historical Society.)

Dwight B. Newton, Western Novelist

Dwight B. "D.B." Newton, prolific writer of Western fiction and television scripts, lived most of his 97 years in Bend, which he discovered during World War II when the US Army assigned him to Camp Abbot in 1943. A graduate of the University of Missouri, where he earned a degree in history and married Mary Jane Kregel, he found Bend the perfect place to write Westerns. Except for an early 1960s sojourn in Hollywood, he lived in Bend until he died in 2013. (Courtesy of Mary Jane Newton and Jennifer Kirkpatrick.)

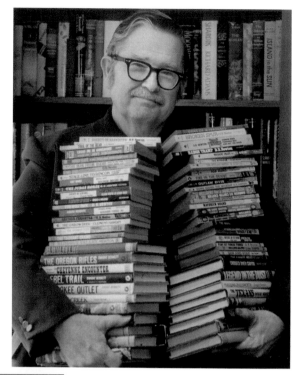

James L. Crowell, Journalist and Writer

James L. "Jim" Crowell moved to Bend from Minnesota with his parents in 1940. A 1955 graduate of Bend High School, he graduated from the University of Oregon in 1960 and began a journalism career at *The Oregonian* before earning a master's degree, teaching at Central Oregon Community College, and specializing in corporate communications. A civic leader, he wrote plays and authored the 2008 book *Frontier Publisher* about George Palmer Putnam's years in Bend. (Courtesy of Jim Crowell.)

Christine Barnes, Writer
Christine Barnes, with her husband, Jerry, moved to Bend from the San Francisco Bay Area in the mid-1990s. Barnes is an author, journalist, and architectural historian who carved out a niche writing about historic lodges. Among her nationally popular books are *Great Lodges of the West* (1997), *Great Lodges of the Canadian Rockies* (1998), and two volumes on *Great Lodges of the National Parks* (2002 and 2012), companion books to the Public Broadcasting System television series. (Courtesy of Christine Barnes.)

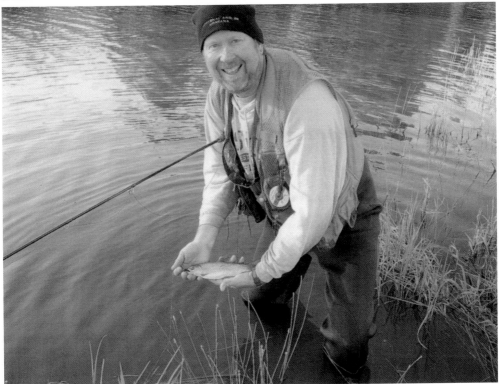

Jim Witty, Journalist
A Californian who earned a journalism degree at California Polytechnic Institute and State University in San Luis Obispo in 1982, Jim Witty worked on several small newspapers before he joined the *Bend Bulletin* in 1999. He soon made his name by covering outdoor recreation for the newspaper. After his untimely death in November 2008, a selection of his articles was published as *Meet Me in The Badlands* in 2009. (Courtesy of the *Bulletin*.)

Michael Gesme, Virtuoso

"We do not simply perform for our community—we perform because of our community," says Michael Gesme, conductor of the Bend-based Central Oregon Symphony. Gesme, with a bachelor's degree in music from Luther College and a master's degree in orchestral conducting from the University of Missouri-Columbia, is also a professor of music at Central Oregon Community College and critical component of Oregon's musical scene. (Courtesy of Michael Gesme.)

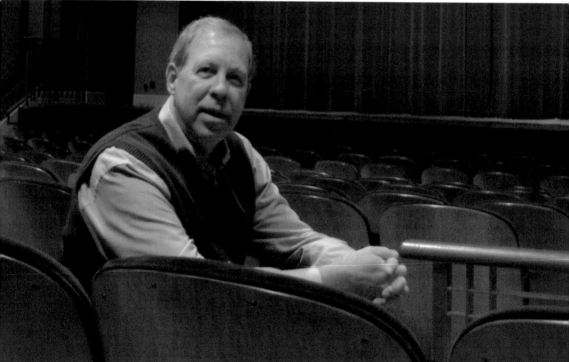

Ray Solley, Impresario

Ray Solley arrived in Bend in April 2009 to become executive director of the Tower Theatre Foundation, the nonprofit organization that owns and manages the city's historic theater. A veteran of Siskel and Ebert's *Sneak Previews* show and one-time talent coordinator for *The Tonight Show with Johnny Carson*, Solley has applied his extensive show business background to making a wide variety of performing arts available at Bend's renovated Art Deco Moderne entertainment venue. (Courtesy of Ray Solley.)

CHAPTER TEN

Athletes and Coaches

In addition to baseball, played even during Bend's pioneering years, the area's environment encouraged alpine sports. An influx of Norwegians and Swedes during the second decade of the 20th century—they came primarily to work in the Brooks-Scanlon and Shevlin-Hixon sawmills—brought skiers with names like Nordeen and Skjersaa who pioneered Bend's winter sports. In the summer of 1923, a group of Bend High School boys decided their sport was mountaineering. They set off to climb the major peaks of Bend's western skyline and climbed several. They then amazed the climbing world when six of them became the first to scale Mount Washington, thought unconquerable by many. Local and out-of-town newspapers—even the *Times* in London—hailed the "Boys of Bend" as they became known in the annals of mountain climbing.

Team sports, such a baseball, soccer, and rugby, are popular, but many Bend athletes seem drawn to individual endurance sports, such as long distance running and bicycling. As reported in the *Bulletin* on June 7, 2015, "scores of runners, cyclists, triathletes and cross country runners" make Bend their home because of "quick and easy access to mountain trails and roads and a robust, supportive community of like-minded athletes with whom to train and recreate." A large population of endurance athletes—as well as professional mountain bikers and climbers—spawns many legendary locals. Outdoor activities, such as hiking, camping, rock climbing, white-water rafting, and kayaking, are very popular with the general populace. Hunting and fishing are popular in Bend's hinterlands. Golf is a sport well provided for in Bend and long enjoyed by many.

Many of the sports closest to Bend's heart are represented in Bend's annual spring Pole Pedal Paddle (PPP) Race. One of the Pacific Northwest's premier athletic events, the 32-mile multisport relay race, which begins on Mount Bachelor and ends in Bend, includes downhill and Nordic skiing, biking, river paddling, and sprinting. Worthy of legendary local status is Justin Wadsworth, winner of eight consecutive PPP races. Along with scores of serious racers, hundreds of community individuals and teams complete the race as a lark.

In addition to athletes who return to their hometown of Bend after making their mark in the sports word, the city attracts its share of famous athlete immigrants. Among these is Drew Bledsoe. Born in 1972 in Ellensburg, Washington, he played high school football in Walla Walla and college football at Washington State University before he was drafted by the New England Patriots in 1993. Bledsoe played quarterback for the Patriots until 2000, for the Buffalo Bills from 2002 to 2004, and for the Dallas Cowboys in 2005 and 2006. He retired in Bend in 2007 with his family and has helped coach Summit High School football.

Ashton Eaton, "World's Greatest Athlete"

Ashton James Eaton, a 2006 graduate of Bend's Mountain View High School and world champion decathlete, won the title of World's Greatest Athlete at the 2012 Olympic Games in London, England. He came home to Bend to celebrate with fans at the Tower Theatre.

Eaton was born on January 21, 1988, in Portland, Oregon, the only child of Roslyn Eaton and Terrance Wilson. His parents separated when he was two years old, and he moved with his mother to La Pine, Oregon, south of Bend. When his mother saw him for the athlete he was and would become, they moved to Bend when he was 10 years old. A few years later, with the help of track coach Tate Metcalf at Mountain View High School, he became state champion in the 400 meters and the long jump. Coach Metcalf urged Eaton to compete in the decathlon. University of Oregon assistant coach Dan Steele, a former decathlete, offered him a partial track scholarship.

Eaton spent a year mastering the skills of the decathlete, including throwing the javelin, discus, shot put, and pole vaulting; all were new to him. In 2008, as an Oregon sophomore, he won the NCAA Outdoor Championships decathlon and was on his way to Olympic greatness. He won many more intercollegiate and international championships along the way, and dominated the June 2012 Olympic Trials in his event. In August, he was off to London. There, he won Olympic gold in the decathlon. Eaton went on to win the 2013 world title in the decathlon in Moscow and the gold medal in the heptathlon at the 2014 IAAF World Indoor Championships in Sopot, Poland. At the August 2015 World Track & Field Championships in Beijing, China, he retained his World's Greatest Athlete title when he broke his own decathlon world record to win his second consecutive world championship title and, including his 2012 Olympic win, his third overall world major in a row. He is currently looking toward the 2016 IAAF World Indoor Championships in Eugene, Oregon; the 2016 Summer Olympics in Rio de Janeiro, Brazil; and the 2017 World Championships in London, England.

Eaton married his University of Oregon teammate, Canadian multi-event athlete Brianne Theisen, on July 15, 2013, a year after both competed in the Olympics. (Courtesy of Jerry Baldock and Outlaws Photography.)

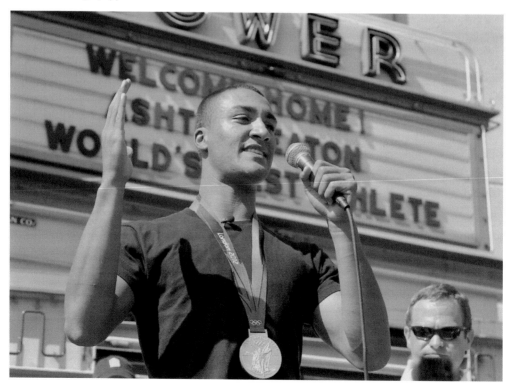

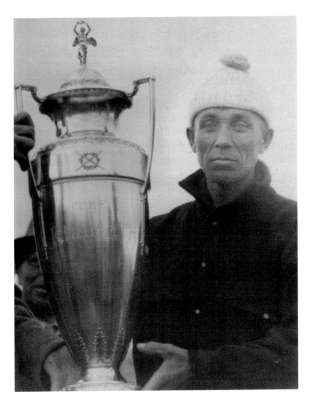

Emil Nordeen and the Skyliners, Alpine Sports Enthusiasts

Winter sports came to Bend with the Scandinavians who arrived to work in the city's sawmills. "As early as 1919—just three years after the Brooks-Scanlon and Shevlin-Hixon mills opened—Chris Kostol, a Norwegian by birth, began skiing alone in the Bend area," Ray Hatton wrote in *High Country of Central Oregon*. Soon, Emil Nordeen, Nels and Olaf Skjersaa, and Nels Wulfsberg sought good skiing in the surrounding high country.

Winter sports took off in Bend in 1927. In February, Nordeen and 23 others competed in Oregon's first long distance ski race from Fort Klamath to Crater Lake. Nordeen won and is shown holding the trophy. In May, Wulfsburg spoke to the Bend Chamber of Commerce about the city's potential to become what geologist Howell Williams in 1944 called "the winter sports center of the Northwest." In December, Bend's skiers formed a club called the Skyliners to enjoy and promote all winter sports as well as alpine climbing and hiking in the summer months.

The Skyliners' interest in winter sports was soon reflected in construction of a ski area on the McKenzie Pass Highway in 1928 and another at Santiam Pass in 1929, almost a decade before Hoodoo Ski Bowl opened nearby. Closer to Bend, the Skyliners, in cooperation with the Deschutes National Forest and aided by Civilian Conservation Corps (CCC) labor, began developing a facility in 1938 near Tumalo Creek, about 10 miles west of town. A large, modern log structure that became known as Skyliners Lodge was completed, as were a ski hill and cross-country trails leading into the backcountry. Also in 1938, a new ski area was developed on Santiam Pass with assistance from the CCC, and in January 1939, the Hoodoo Ski Bowl was dedicated.

The Skyliners also enjoyed late spring and early summer skiing on Bachelor Butte (eventually renamed Mount Bachelor), where development of skiing facilities occurred after World War II. After US Forest Service approval was granted to visionary Bend businessman and skier Bill Healy, Mount Bachelor Ski Area, complete with a warming hut and poma lift tow, opened in 1958 to serve 10,000 skiers. Bend's future as "the winter sports center" it became was assured. (Courtesy of Deschutes County Historical Society.)

Gene Gillis, Olympic Skier

Born in Bend in April 1925, Gene Gillis graduated from Bend High School, played football at the University of Oregon, served in the US Marine Corps during World War II, was a member of the 1948 US Winter Olympic ski team, coached junior skiers in Bend, and helped develop Mount Bachelor as a ski resort. He also helped develop winter sports areas in Colorado, where he died on December 9, 2005. (Courtesy of Deschutes County Historical Society.)

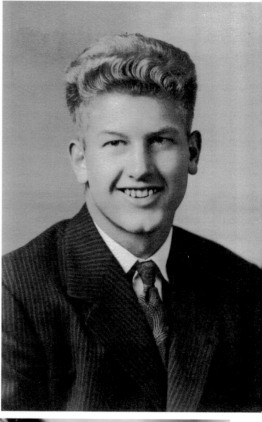

Christina Cutter, Olympic Skier

Born in Bend in July 1949, Bend High School graduate Christina "Kiki" Cutter learned to ski and race at Mount Bachelor and won the US junior downhill championship in 1967 at age 17. At 18, she made the US Olympic Team and, in the 1968 Winter Olympics, was top American woman and only American woman to ski in all three events—slalom, giant slalom, and downhill. After five World Cup victories, she retired from international competition at age 20. (Courtesy of National Ski and Snowboard Hall of Fame.)

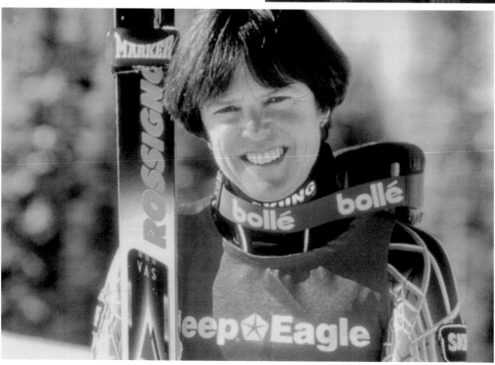

Bend Elks, 1936 and 1937 Baseball Champions

Baseball became America's pastime in the late 19th and early 20th centuries, when more people in the United States watched and played baseball than any other sport. Bend brags over 100 years of baseball history, and some of its teams and players became local legends.

As early as 1903, the yet-to-be-incorporated settlement on the Deschutes River had a woman's hardball team called the Bend Beauties. Whether they played ensuing seasons depended on which players got married; it wasn't thought proper for married ladies to be playing baseball in their bloomers and red sweaters.

Bend baseball continued with diverse teams, leagues, and sponsorships. In 1911, athletes from Bend and Redmond played as a team called the Bend Reds. Players on Bend's 1913 team included such city fathers as Clyde McKay, Dr. Urling C. Coe, and George Palmer Putnam. Baseball games became an essential element of Fourth of July celebrations in the Bend of the Roaring Twenties and the Great Depression.

In 1936 and 1937, the original Bend Elks (above)—the only Oregon State League team east of the Cascades—won the league championship. On the team were John Bubalo, who became a physician associated with the Portland Medical Center; John Londahl, who became a US Army general; and Paul Gehrman, who became a major league pitcher. That team was the descendant of teams once sponsored by the Bend Chamber of Commerce, then by the Eagles civic club as the Eagles, and then by the Elks.

More recently, Bend has fielded five Northwestern League teams. In 1970 and 1971, that team was the Bend Rainbows, for which actor Kurt Russell played second base in 1971. It was the Timber Hawks (1978); the Bend Phillies (1981–1987), a farm team for the Philadelphia team; the Bend Bucks (1988–1991); and the Bend Rockies (1992–1994), a farm team for the Denver team. From 1995 to 2000, the semi-pro Bend Bandits played in the independent Western Baseball League. Since 2001, the current Bend Elks have played as a West Coast League summer collegiate team.

In 2015, new owners in Lake Oswego, Oregon, purchased the Bend Elks to continue to play at Vince Genna Stadium in Bend. (Courtesy of Deschutes County Historical Society.)

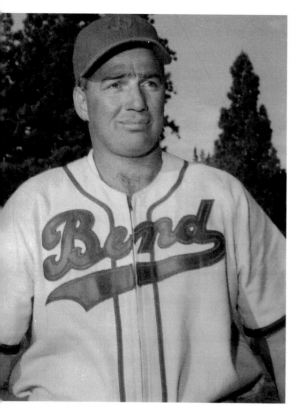 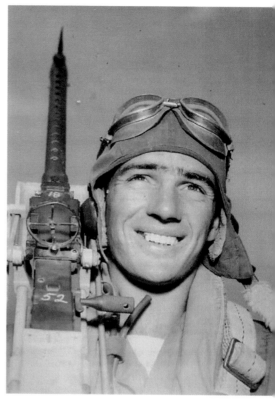

Vince Genna, Parks and Recreation Developer

Vince Genna, who built and headed Bend's park system for more than 30 years—and for whom the city's baseball stadium is named—was born in Auburn, Washington, on New Year's Day, 1921. A student at Willamette College in Salem, Oregon, Genna received both a contract to play for the New York Yankees and a draft notice from Uncle Sam in the mail on the same day in 1942. He served in a US Army Air Force B-24 bomber crew based in Manduria, Italy, for the duration of World War II. He was awarded a Bronze Star Medal for that service but sustained a shoulder injury that ruined his chances to play big league baseball.

"Baseball's loss was Bend's gain," the *Bulletin* eulogized Genna when he died in 2007 at age 85. Genna moved to Bend with his wife and two sons in 1954 after sawmill owner Leonard Lundgren, who wanted good baseball in the city, offered to pay his salary. Genna started as Bend's assistant recreation manager that year and worked his way up to head what is today's Bend Parks and Recreation District. All that time, Genna coached and promoted baseball and worked tirelessly to acquire land for and to develop Bend's parks. (Both photographs courtesy of Deschutes County Historical Society.)

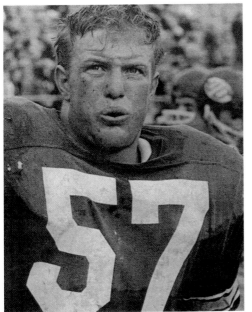

George Dames, College Football Star
Born in San Diego, California, George Dames grew up and played high school football in Medford, Oregon. A walk-on at the University of Oregon, he was one of the smaller players to play middle guard for the Ducks. A three-year letterman from 1966 to 1968, he dominated opposing defenses during his senior year and received many honors. Dames moved to Bend in 1991 to pursue the investment business. He was inducted into the University of Oregon Athletics Hall of Fame in 2000. (Courtesy of George Dames.)

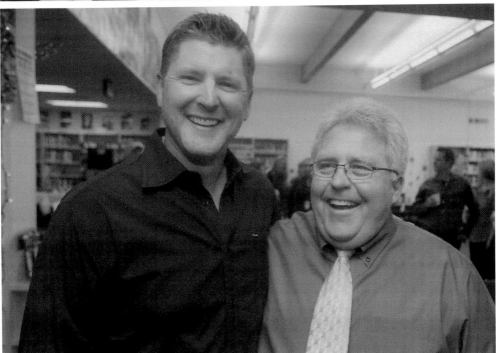

Ryan Longwell, Professional Football Star
A 1992 graduate of Bend High School, where he played football and baseball, Ryan Longwell (left) played football at the University of California and for 16 seasons in the National Football League. He was a placekicker for the Green Bay Packers from 1997 to 2005 and then kicked for the Minnesota Vikings from 2006 to 2011 and for the Seattle Seahawks in 2012, before he retired. Longwell reunited with Craig Walker (right), his Bend High School football coach, in October 2014. (Courtesy of the *Bulletin*.)

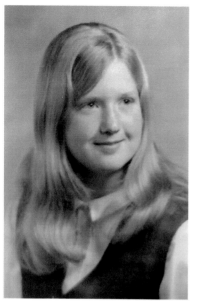

Lynne Winbigler, Olympic Discus Thrower
A 1971 graduate of Bend High School, Lynn Winbigler won the 1976 US Olympic Trials in the discus, became Oregon's first female Olympian, and launched her four-year reign as the top woman discus thrower in the United States. Her longtime goal of competing in the 1980 Olympics was dashed by the US boycott. Inducted into the University of Oregon Track & Field Hall of Fame in 1992, Lynn Winbigler Anderson coached and taught at the University of Minnesota. (Courtesy of Polly Gribskov.)

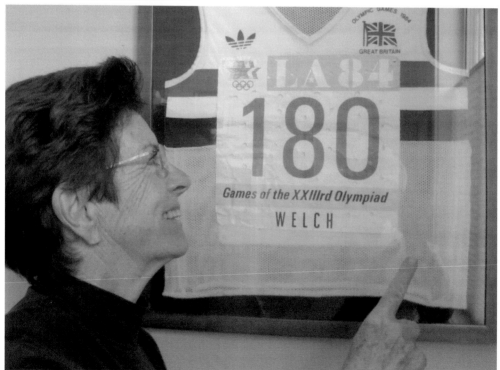

Priscilla Welch, Olympic Marathoner
A petty officer in the Royal Navy for 15 years, Priscilla Jane Welch—a Bend resident since 2001—began her marathon running career at age 35. Four years later, she finished sixth in the first women's Olympic marathon at the 1984 Los Angeles Olympics. She won the 1987 New York Marathon. A Nike-sponsored athlete, she and her late husband–coach, David Welch, lived in Boulder, Colorado, for 17 years. She was inducted into the US National Distance Running Hall of Fame in 2008. (Photograph by Les Joslin.)

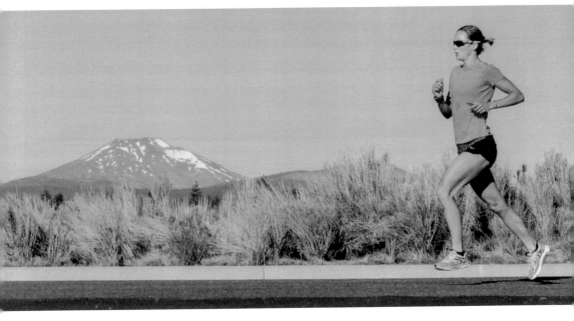

Linsey Corbin, Triathlete

Linsey Corbin (maiden name Pickell) is a professional triathlete who lives and trains in Bend, where she grew up and graduated from Mountain View High School in 1999. Corbin left Bend to attend the University of Montana, where she met her husband, Chris, and began her triathlon career. She has claimed five Ironman titles and holds the American female record for Ironman distance. In 2014, after 13 years in Missoula, she returned to Bend for family and training reasons. (Courtesy of Linsey Corbin.)

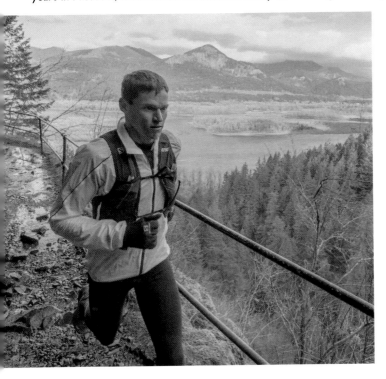

Max King, Long Distance Runner

Max King was born in Central Point, Oregon, where he graduated from Crater High School in 1998. He ran at Cornell University, graduated in 2002, moved to Bend, and kept running to become one of America's best and most versatile distance runners. On November 21, 2014, he proved that again by winning the International Athletic Union 100K World Championships in Doha, Qatar—the second world championship title of his career. (Courtesy of Paul Nelson Photography.)

Jonathan Stewart, Long Distance Trekker

Jonathan "Jon" Stewart of Bend is an avid and accomplished long distance walker. Since retirement in 2005, he has trekked the Pacific Crest Trail, recalled in his 2010 book *Pilgrimage to the Edge*; the Continental Divide Trail, recorded in his 2014 book *Walking Away from the Land*; Canada's Great Divide Trail; Vermont's Long Trail; and the Hayduke Trail through Utah and Arizona. He is shown below on the Pacific Northwest Trail in Glacier National Park.

Born in 1947 in Medford, Oregon, Stewart earned degrees in history and journalism at the University of Oregon and served in the Peace Corps in Nepal. During his US Forest Service career, he was a backcountry ranger, smokejumper, fire management officer, volunteer and partnerships coordinator, and executive director of the Northwest Service Academy, the nation's first conservation-oriented AmeriCorps program. A tree farmer, he serves on the Northwest Oregon Regional Forest Practices Committee. (Both photographs courtesy of Jonathan Stewart.)

BIBLIOGRAPHY

Abernathy, Jon. *Bend Beer: A History of Brewing in Central Oregon.* Charleston, SC: History Press, 2004.

Barnes, Christine. *Central Oregon: View from the Middle.* Helena, MT: American and World Geographic Publishing, 1996.

Brogan, Phil F. *East of the Cascades.* Portland, OR: Binford and Mort Publishers, 1971.

Coe, Urling C., *Frontier Doctor: Observations on Central Oregon and the Changing West.* New York, NY: Macmillan Publishers, 1940.

Crowell, James L. *Frontier Publisher: A Romantic Review of George Palmer Putnam's Career at the Bend Bulletin.* Bend, OR: Deschutes County Historical Society, 2008.

Deschutes County Historical Society. *Bend, Oregon: 100 Years of History.* Bend, OR: self-published, 2004.

———. *Images of America: Bend, Oregon.* Mount Pleasant, SC: Arcadia Publishing, 2009.

Hatton, Raymond R. *Bend in Central Oregon.* Portland, OR: Binford and Mort Publishing, 1986.

———. *High Country of Central Oregon.* Portland, OR: Binford and Mort Publishing, 1987.

Haynes, Ted, and Grace Vandevert McNellis. *Vandevert: The Hundred Year History of a Central Oregon Ranch.* Palo Alto, CA: The Robleda Company, 2011.

Joslin, Les. *Ponderosa Promise: A History of US Forest Service Research in Central Oregon.* Portland, OR: US Department of Agriculture, Forest Service, Pacific Northwest Research Station, 2007.

Perry, Walter J., ed. Les Joslin. *Walt Perry: An Early-Day Forest Ranger in New Mexico and Oregon.* Bend, OR: Wilderness Associates, 1999.

Riis, John. *Ranger Trails.* Richmond, VA: The Dietz Press, 1937. (Reprinted by Wilderness Associates, Bend, OR, in 2008.)

St. John, Alan D. *Oregon's Dry Side: Exploring the East Side of the Cascade Crest.* Portland, OR: Timber Press, 2007.

Vaughan, Thomas, ed. *High & Mighty: Select Sketches about the Deschutes Country.* Portland, OR: Oregon Historical Society, 1981.

Williams, Elsie Horn. *The Bend Country: Past to Present.* Virginia Beach, VA: The Donning Company, 1998.

INDEX

INDEX